Modern Wedding Photography

Modern
Wedding Photography

Suzanne Szasz

AMPHOTO
American Photographic Book Publishing Co., Inc.
Garden City, New York

Acknowledgments

My special thanks to Betty Warner for giving me my first wedding photography job; and to my husband, Ray Shorr, and editor, Shirley Keller, for their patient and knowledgeable editing of my manuscript.

Published in Garden City, New York, by American Photographic Book Publishing Co., Inc. All rights reserved. No part of this book may be reproduced in any form without the written consent of the publisher.

Library of Congress Catalog Card No. 76-16680

ISBN 0-8174-2411-3

Manufactured in the United States of America.

Contents

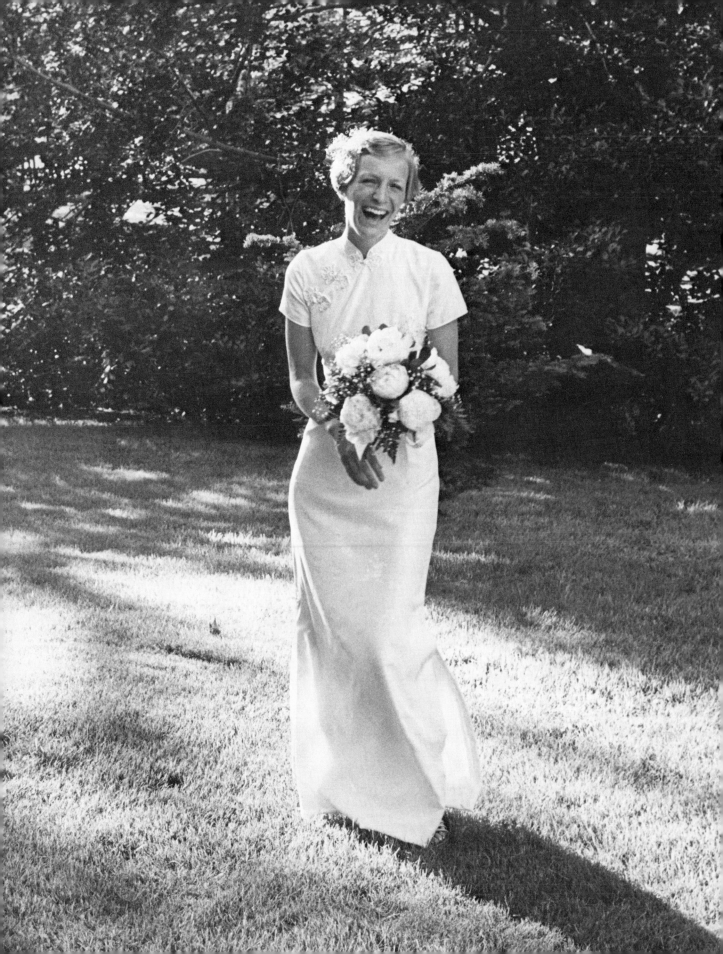

Wedding Customs and Their Origins

Every wedding is a strange blend of racial and national customs handed down from ancient times. Today's bride may be wed in a Gothic cathedral, and come down the aisle to German music from Wagner's Lohengrin. She may be wearing a Jewish coronet made of pagan orange blossoms topping a Greek veil, on her finger, a Roman ring. She may kneel like an ancient Egyptian bride, and she has possibly signed a marriage contract made up by the Anglo-Saxons of old.

A few more interesting tidbits:

Many weddings are held in June not only because of the warm, pleasant weather, but because, according to the ancient Romans, May was an unlucky month.

Greek and Roman brides were covered with a thin cloth called the *flammeum* during the ceremony; the veil represents this custom.

In medieval times, people wore signet rings to put their seal on contracts and agreements; today's wedding band symbolizes this custom.

Richard the Lionhearted brought back the orange tree from the Crusades. When people observed that it bore flowers and fruit simultaneously, it became the symbol of fertility; that's why brides wear wreaths of orange blossoms today.

Among most primitive peoples, men stole their brides, then hid till the father's anger subsided. As time was then reckoned by the changing moon, and this time was sweet, we can understand why the period after the wedding is still called the *honeymoon.*

When the couple leaves the wedding, they still pretend to flee, as though irate fathers and brothers were pursuing them.

The Basics of Wedding Photography

It should help both me, the author, and you, my readers, if we agree on whom this book is written for.

Basically, for two groups of people.

First, for those who, like me a few years ago, have never photographed a wedding but would like to expand their photographic horizons. I am thinking particularly of those who have gone from occasional amateur photography to small jobs—maybe from recording their own children they have gone on to child portraiture—and who are now ready to photograph weddings too. I hope this book will add to their knowledge.

The second group—further removed from me in experience and philosophy—is made up of people who started out as helpers or apprentices in a commercial studio specializing in weddings. They have been told about all the obligatory shots and tricks of posing, and they have faithfully come back with the same 10 to 20 wedding pictures time after time. Now they realize that they are no longer satisfied with their work. I would like to show this group that freedom and respect for individuality *can* be achieved, even though it may take a little more time and effort. And I hope this book will inspire them to try this different approach to wedding photography.

My first excursion into wedding photography took place when Wendy, whom I had known and photographed since she was seven years old, told me she had just become engaged and asked whether I would photograph her wedding. At first, I was dubious; but I like challenges and new assignments, so I said yes.

I reminded myself that during the existence of such picture magazines as *Life, Look,* and *Saturday Evening Post,* I had photographed many events that were as nonduplicable as a wedding, and I had always been able to bring back the pictures. I knew I would have to work out a balance between having enough equipment to cover all situations and looking like a walking camera store. So I tried to imagine in advance what I would need, and where, and to distribute my equipment accordingly.

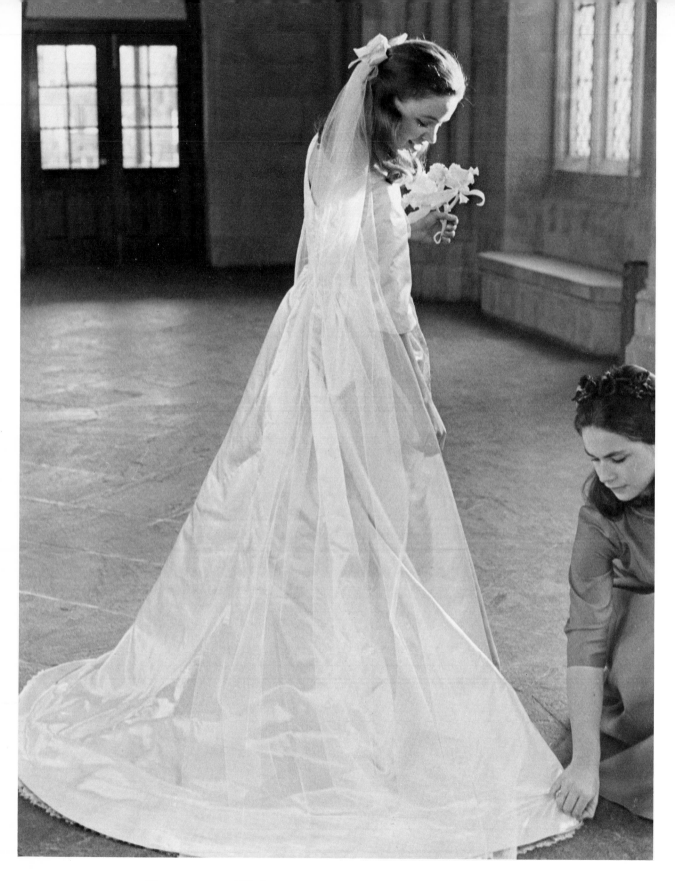

For more details of that first wedding coverage, see Chapter 4. Let me just say here that it was such a success that many of Wendy's friends asked me to cover their weddings as well. And I found that I enjoyed each new setting, each new group of excited, happy people, each new drama of change that a wedding brings.

The books and articles I read on wedding photography were less than I had hoped for, inasmuch as their authors seemed to believe they could only produce good coverage if they constantly posed, guided, even badgered their subjects. One author advised all wedding photographers that it was their DUTY to take over, because they were the only ones who knew what came next and what the couple had to do. "Never mind if they dislike you at the wedding," one proclaimed, "they will thank you when they see the beautiful pictures."

Well, I would rather not spoil a wedding and still make everybody happy with the pictures, so I try to be as inconspicuous as possible. I work alone—by choice—just for this reason, and I have found that I can always find someone among relatives or friends who is eager and willing to help me by pointing out the family's best friends and other relatives; by keeping

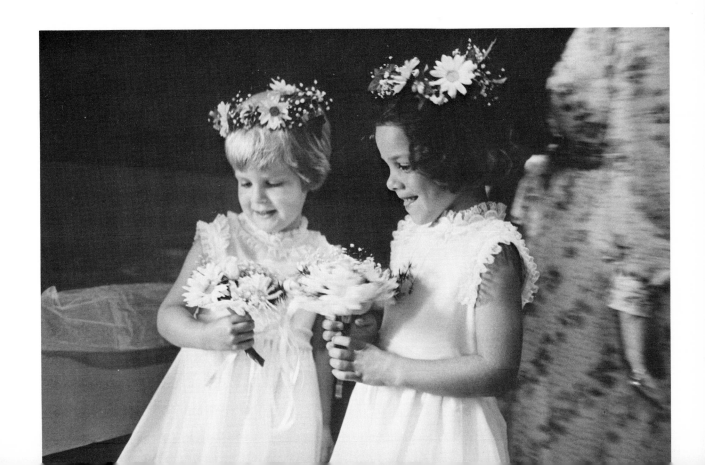

others from stepping in front of me when a crucial moment arrives; and by tipping me off when the bride and groom are ready to cut the cake or leave for the honeymoon trip.

My feeling is that I am there to record the day, not to arrange it according to what I have seen happen at other weddings. Naturally, I make sure that I get good photographs of everyone, but otherwise I just try to absorb the atmosphere and take the best pictures I can. Nothing pleases me more than a new arrangement of the receiving line or an unusual cake (handmade by the bride and half-melted, in one case!); a ray of light illuminating the bride while she enters church; children overawed by the events; grandparents possibly making their last appearance at such a complete family gathering; a couple that really enjoys the dancing and music hour after hour. There is something new at each wedding.

Before examining all the situations that may confront you when covering a wedding, I would like to tell you something about the way I work, and the cameras, lights, and films I like to use. The best teacher is experience, but the next best is someone who is willing to share their experience with you.

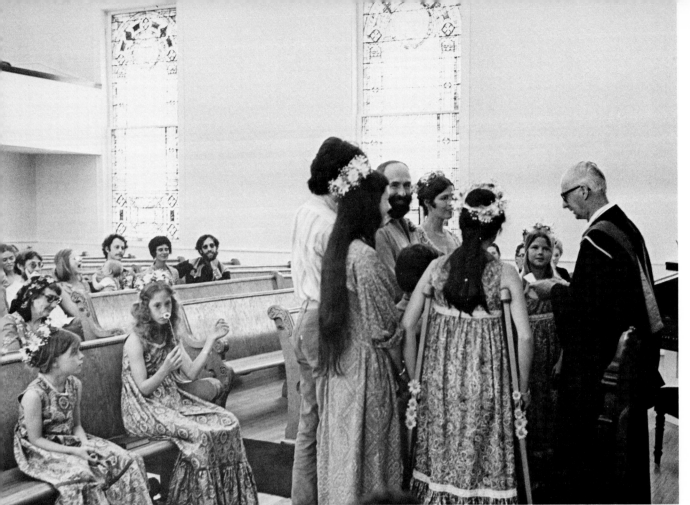

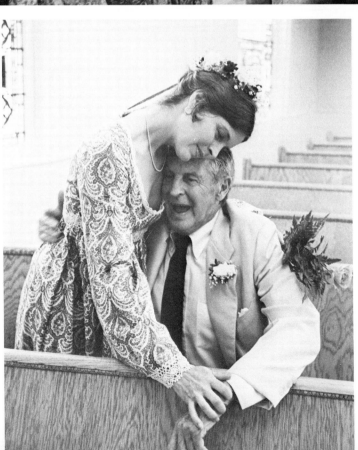

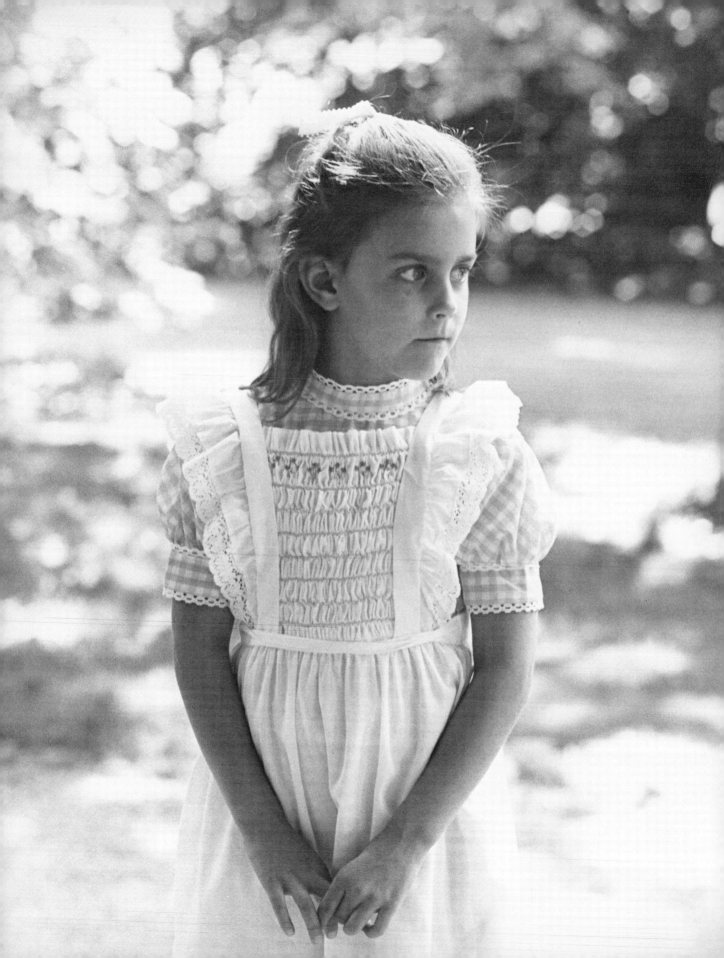

Equipment CHAPTER 1

CAMERAS

With cameras, as with most things in life, you have to pay for everything you want. The 35mm single-lens reflex cameras, like the Nikon and Minolta, are the most pleasant to use. You see everything as it will appear in the finished print or slide. However, such cameras are heavier and noisier than the range-finder cameras. The latter are silent and featherweight, but composition is harder to judge because of the problem of parallax. Rolleiflex-type cameras using size 120 film are wonderful in many respects. They give you beautiful negatives, although you have to reload after 12 shots and the lenses are not interchangeable. With the $2\frac{1}{4}'' \times 2\frac{1}{4}''$ Hasselblad-type cameras, you still have to change film after 12 exposures, but you have the luxury of inter-changeable lenses—a very important feature in wedding photography, where different situations demand different lenses. But such cameras are more expensive and heavy, and I have trouble changing film without a place to put the camera parts down.

So how do you choose your cameras? It takes a combination of practi-cality, financial considerations, the influence of another admired photog-rapher, or just plain fancy.

In my case, it was all of these reasons, combined with a reluctance to try something new all the time, which has made me stick with the Minolta system for years now. As they modernized their equipment, introducing built-in light meters, for instance, I became more modern too. Now the outfit I use most often consists of two SR-T 102 bodies, with a 55mm lens on one and an 85mm lens on the other. I also carry a 100mm telephoto lens and a rangefinder camera with wide-angle lenses.

Beginning photographers tend to fall into one of two categories when choosing a camera. The first group cares less about the finished picture, as long as it is made with the fanciest camera, lens, or gadget. The second group dislikes cameras with anything more than two small knobs; I think these

people deprive themselves of much pleasure and the better results that understanding a better though more complicated camera would bring.

I started out from this second group, rather afraid of complicated machinery. One day I was trying to bake a cake in less time than the recipe called for, and so increased the heat a bit. It hit me then that that's exactly what one has to do with shutter speeds and lens openings. When you change the ratio between time and temperature in the oven, the cake will either be done or moist in the middle. In photography, in comparison, the basic procedure is the same. Longer exposure time = smaller lens opening; shorter exposure time = larger lens opening. A wide-open lens will result in shallow depth of field, a long exposure in a blur. The choice is up to you and what you want in a photograph.

LENSES

A few words on the most important part of your camera: the lenses. Fixed-lens cameras come with so-called normal lenses (45–58mm on 35mm cameras and 75–80mm on 2¼″ × 2¼″ cameras). With cameras that accept interchangeable lenses, you can use all lenses.

Telephoto lenses see less than normal lenses, but bigger; with them, you can "fill the frame" of a 35mm negative with the subject's head. From the same place, a normal lens will also give you the upper body of your subject. A wide-angle lens will add the legs too.

Outdoor portraits of the bride, taken from the same spot with 35mm wide-angle, 55mm normal, and 100mm telephoto lenses on my Minolta SR-T 102 camera.

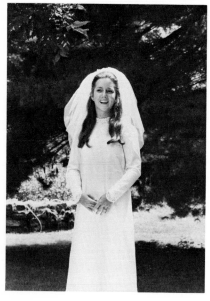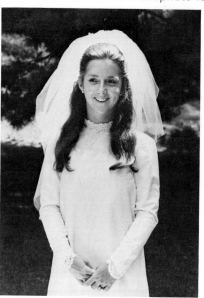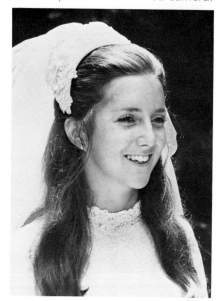

16

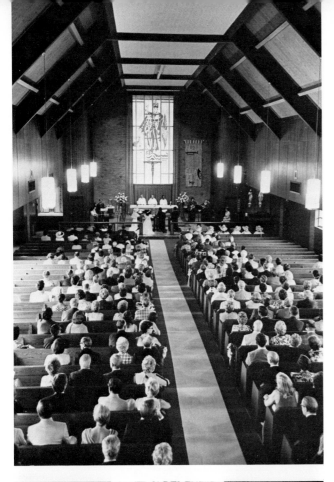

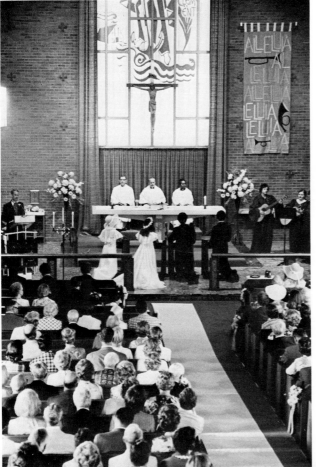

Two views from a church balcony: the first taken with a 55mm normal lens, the second with a 100mm lens. Both: available light, 1/30 sec. at f/5.6, Kodak Tri-X Pan Film rated at ASA 800.

17

Telephoto lenses (85mm, 100mm, 135mm, and so on for 35mm cameras) have a shallow depth of field, so you have to focus more carefully. Wide-angle lenses (35mm and shorter on 35mm cameras) have a greater depth of field, so that not only your subject, but the background as well will be sharp. This may or may not be what you want, depending on how good or distracting the background is.

SHUTTERS

I wish you didn't have to worry about what shutters different cameras have, but you do. Wedding photography is practically unimaginable without flash and speedlight (electronic flash) synchronization. Ideally, you should be able to shoot flash at all shutter speeds, but that is possible only with Compur-type shutters, which are generally found only on fixed-lens cameras. The most popular 35mm cameras use focal-plane shutters, which need at least 1/50 sec. or 1/60 sec. so that the whole negative is illuminated by flash or electronic flash. If you use either as your main light, this is not much of a problem; but it is less than ideal when you use flash only as a fill-in light. See pages 32–36 for more on this.

All exposure meters except spot meters will be fooled in this situation and will read the light background instead of your subjects' faces. Open up at least one, possibly two, stops on your lens.

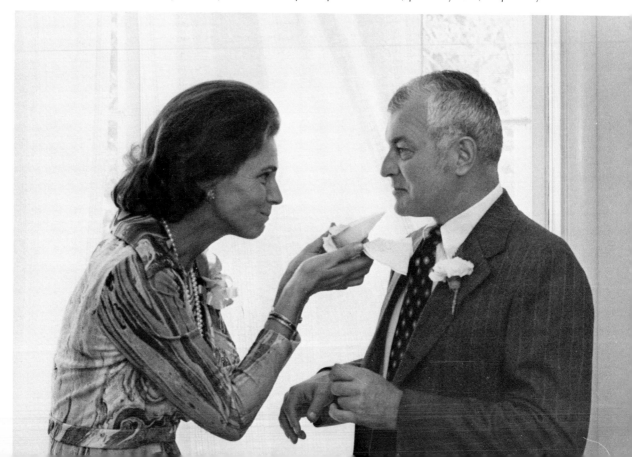

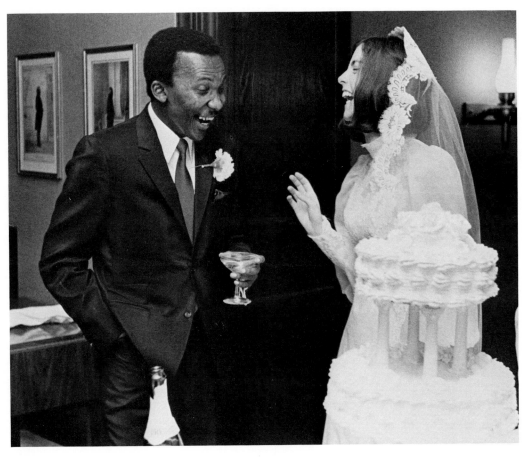

Situations of extreme contrast demand careful evaluation and compromise. No fully automatic camera can do this; experience and intelligence are still needed.

EXPOSURE METERS

Whether the meter is built into the camera or is separate, it is an indispensable tool for professional photographers. Anyone who really understands the workings of an exposure meter already understands most of the technical part of picture-taking. The first step is to know and set your ASA film speed, then look at all the exposures that are correct with your film. It is up to you to learn to choose wisely among them. For instance, do you want to stop action with a fast shutter speed? If so, then your *f*/stop will have to be correspondingly larger (in the lower numbers). Or do you want to stop down to *f*/11 in order to show several people and the background sharply? If you do, then your shutter speed, or exposure time, will have to be longer.

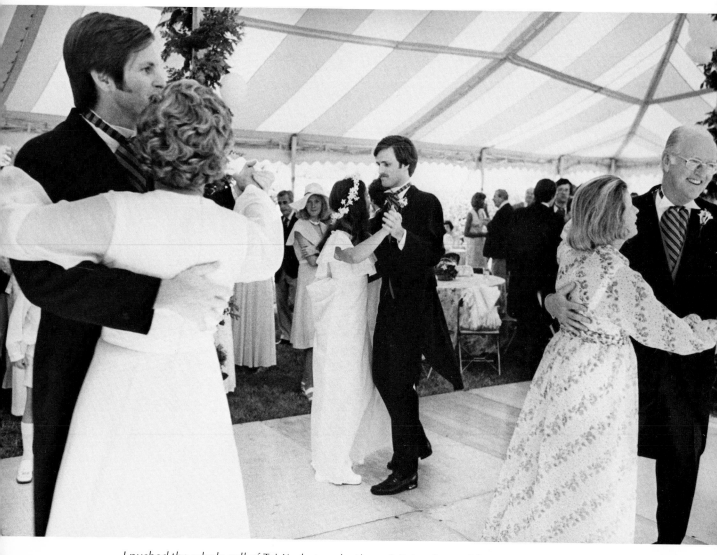

I pushed the whole roll of Tri-X, shot under the soft light of a wedding tent, to ASA 1600 by developing two to three minutes longer than the recommended time (by inspection, of course). 35mm lens, 1/125 sec. at f/4.

The more you study your light meter, take imaginary pictures, or, better yet, take pictures as tests, the more confidence you can have so that in the demanding situation of a wedding, you will make the right decisions fast. One test roll will convince you of something very important: Unless you have a chance to take a close meter reading right on the face of your subject, the brightness or darkness of the background can fool any meter, built-in or not, whether reflected light or the incandescent type.

Try this: Set up a couple of lights in front of a white background and ask someone to stand in front of it. Take a meter reading from camera position. Now change the background to black cloth without changing the lighting setup. Read your meter again. It should register about two stops less with the white background than with the black one. Meanwhile, your purpose, which was to photograph a person, hasn't changed a bit! The truth lies somewhere in-between the two meter readings, and some cameras now try to take this into consideration. But it is safer to open up your lens one more *f*/stop if the background is white, and stop down one more *f*/stop if it is black.

Simple, you say? Well, I must confess that this question of the brightness of the background has given me more trouble than anything else. For this reason, I make a note of extremely light or dark backgrounds by writing on my film tongue after I finish shooting; when I develop by inspection later, I won't be fooled again. Invaluable!

AUTOMATION

It is quite possible that I don't meet enough beginning photographers and so have yet to meet one who started out with automatic cameras and developed into a good photographer. The beginner would blame all mistakes on the camera and never learn the basic steps and concepts that are essential for improving as a photographer.

Someone told me recently that I was prejudiced, that some functions have been taken over by machines and automation these days. Why bother to learn to shift gears on a car when all cars will soon have automatic gear shift only? the argument goes. Or why learn to multiply when computers are so much more accurate than our brains? Well, I still believe that we must first learn to multiply and then we can let machines help us. And, we should learn the rudiments of camera machinery before we let automation do it for us.

So, contradictory as this may sound, I am all in favor of automation for photographers who have already gained some experience and know what their automated cameras are doing. They will know how to get the most out

of automation, and their job will be made easier at the same time.

Automation is not cheap. If you have a choice between acquiring one super-duper automated camera with a fixed lens or a simple but good camera with two or three lenses, I'd advise you to choose the latter. If you do, you may even have money left over to buy an extra body, and then you will be really ready to cover a lot of situations.

I never use *fully* automated cameras in which both aperture and shutter speed are set by a photoelectric cell. I am constantly watching how much to compensate for different backgrounds as against what my built-in light meter tells me, so the idea that one should just set the film speed in a camera and leave the rest to *it* is unacceptable to me.

FILMS

Black-and-white. Even after personally trying out all the newest, supposedly faster films that were introduced after Kodak Tri-X Pan, I kept coming right back to it. I generally rate it at ASA 800 (as against Kodak's ASA 400 rating) because I find that grain can become objectionable if the film is overexposed. I develop my rolls for the normally prescribed time, then inspect it by green light, and add another minute or, at the most, two if I find this is needed.

Tri-X is especially effective in soft, even light. I never use it in sunlight outdoors but keep another camera handy, loaded with Kodak Plus-X Pan film. To be sure which camera is loaded with a particular film, I don't rely solely on the tiny numbers on the camera; I write the ASA speed of my film, and "color" or "b & w" on a piece of masking tape and stick it on the back of each camera. I even have a colored masking-tape system worked out (green for Tri-X, and so on). Once you work out something for yourself, you will see how it helps cut down on goofs.

Color. Again, Kodak films stand out. For wedding photography, I use Kodak Vericolor II, Type S (ASA 100). Many wedding photographers use negative color film exclusively, reasoning that it can also give black-and-white prints on Panalure paper. But I prefer to shoot color and black-and-white separately so that I can take advantage of the higher speed of black-and-white film.

Until manufacturers invent color film that approximates Tri-X for speed and flexibility, I shall always prefer to limit my color shooting to scenes that really benefit from color.

If it comes to a choice between direct-flash color and black-and-white without flash, I prefer black-and-white. Curiously enough, it often looks more professional too. Any amateur with a simple camera and a flashbulb can

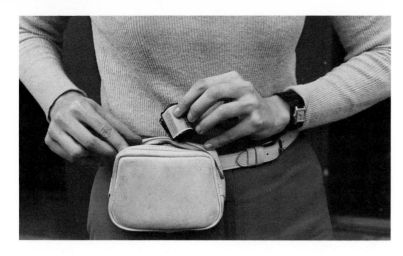

I carry four to five rolls of film, a marking pen, a tiny flashlight, and a clear plastic bag for exposed film in this ski pouch.

produce direct-flash color shots that differ very little from what I can do in a similar situation in color. But let me shoot by available light—where the amateur would not dream of getting a shot—and I can be certain that no cousin with his Instamatic will have already shown the bride's parents a similar picture.

Let me clarify: I love color photography where it is easy to do (outdoors, for instance) or where I can use more than one light source, reflector, and anything else that will produce natural-looking color photographs. Unfortunately, weddings don't allow us this luxury, so I prefer to compromise and use both color and black-and-white. So far, all my clients have seen my point and have allowed me to use my judgment.

ACCESSORIES

There aren't many accessories that are needed or useful in wedding photography. Among the few that are is the *sunshade (lens hood)*. I never take mine off, and they stay on even when I exchange lenses. My camera cases accept the cameras with the sunshades in place. I think they are necessary not only when shooting against the light, but in all circumstances. They will eliminate stray light hitting your lens and thus will make your photographs sharper.

I keep only two *filters* in my gadget bag: a K2 yellow filter for black-and-white film, which is useful in lightening the complexion of a bride whose skin is suntanned. (See Chapter 3: Bridal Portraits for more on this subject.) The other is a Kodak Skylight (1A) filter for warming up color shots, especially when taken in open shade; but because I like the slightly warm tone it produces, I often leave this filter on for other situations as well. Should I forget to remove it for black-and-white shooting, it will not affect anything and it does not change the exposure.

I always carry a small *brush, blower, and lens tissue* to clean all my lenses just before I start photographing. My blower is really an ear syringe, available in all drugstores. After blowing off dust from the lenses, I brush them with a

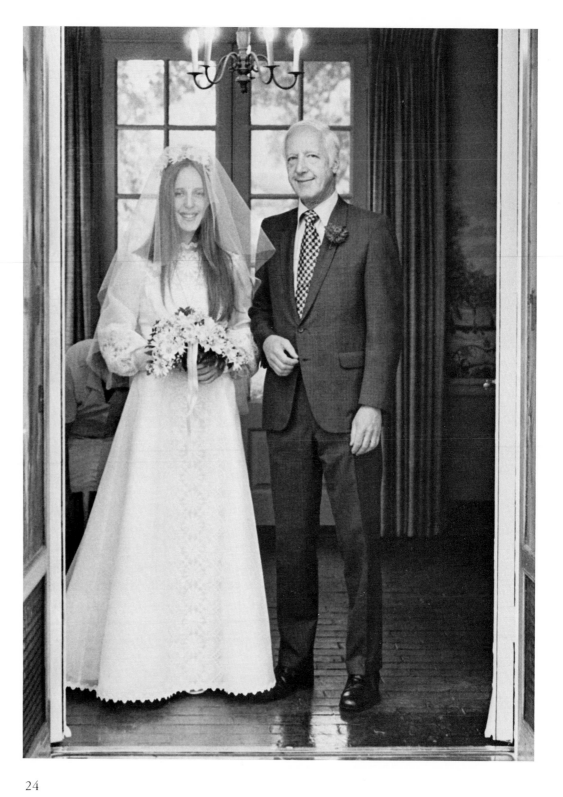

small lens brush that looks like a lipstick when closed (sold in camera stores). Only after I do this do I use lens tissue, otherwise I would be grinding dust into the sensitive surface of coated lenses.

For wedding photography, it is very important to have just the right *camera bags*. (On pages 27–28, I describe which equipment I carry in each bag when covering a wedding.) Try (and this won't be easy) to find one in which you can arrange your cameras properly, which means, READY FOR USE. I have seen beautiful big camera bags into which three or four cameras, plus extra lenses, filters, light meters, and film had been thrown so carelessly that it must have taken at least 15 minutes to get anything ready for shooting. There is also danger of scratching your equipment in such a disorganized large bag.

The opposite of this mess is the small, minutely and expertly compartmentalized bag, which has to be packed so exactly that it is impossible to replace a camera once the lens cap has been removed and the sunshade put on, or even when the lens is extended. Such an arrangement may be fine for the landscape photographer, who can take all the time he wants, but not for those of us who need to be ready to shoot fast while also protecting our equipment. So we need a bag large enough to hold at least one camera with its sunshade on and wrapped in plastic bubble-packing material, plus an extra lens or two similarly protected.

The next item is not strictly a camera accessory, but I would never go out without it. I'm talking about my belt and film pouch, the kind skiers and hikers use. It holds four to five rolls of film, a marking pen, a tiny flashlight, and a clear plastic bag into which I put my exposed film.

PHOTOFLOOD LIGHTS

At the risk of being considered foolish, old-fashioned, or worse, I must confess that I use photofloods on most wedding assignments. You can read why and how I do this on pages 38–41.

I carry two featherweight, collapsible PIC light stands. My lighting fixtures mount two ways: either to the top section of the stand via a socket fixture, or by clamp to any shelf or ledge.

If you cannot find this double (and doubly useful) attachment in your camera store, buy a ball-joint socket, a small set screw, and put the unit

There's nothing like a bounced photoflood to boost available light and give natural-looking results. 1/125 sec. at f/5.6, Tri-X.

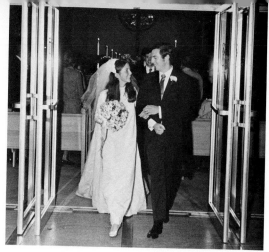

Direct electronic flash prefocused on the doorway, f/8 from ten feet away.

together yourself with a clamp fixture. They usually come with no more than 6 feet of wire, so I carry an extra 12- to 15-foot medium-weight extension cord for each fixture. I also have a 50-foot cord in my car for unusual situations.

Bulbs. The bulbs used in photofloods are either 500-watt *reflector floods*, made by GE, average life 6 hours; or 375-watt *photofloods*, made by Sylvania, average life 15 hours. Also available are movie lights of many kinds, either tungsten or quartz-halogen; and quartzline incandescent lamps, which are cooler, longer lasting, and retain their color temperature.

FLASH AND STROBE

The array of flash and electronic flash equipment is really impressive. It seems nearly impossible to choose until you realize what you want and need from a flash for wedding photography. Then the choice narrows down to three or four manufacturers: Braun, Honeywell, Metz, and Minolta.

In choosing an artificial light source for wedding photography, bear in mind that the time it takes to change bulbs could mean missing some important shots; moreover, it also costs more to use flashbulbs. But whether you use flash with bulbs or electronic flash, the results should be the same. I always carry a miniature Canon Quint flash with me; it holds five small bulbs without reloading. Other multiple-bulb flash attachments are available.

Below are factors you should consider when selecting flash or electronic flash equipment:

1. Your unit should not be too heavy or bulky.

2. It should give you at least 2000 to 5000 BCPS (beam candlepower seconds), which yields a useful guide number of 50 to 100 for an ASA 100 film.

3. It should have an easily attachable bracket for your camera so that it forms a comfortable unit with it. This leaves one hand free for focusing and shooting.

26

4. It should recycle fast; five seconds is normal, three seconds very good. That means a rather large battery, which is not cheap but is essential. Small nickel-cadmium batteries may not last through one whole wedding!

5. It should be easy to use the unit for bounce; that means, a different adjustment on the bracket, and, in the case of an automatic flash unit, a separate sensor.

6. Ideally, it should also operate on AC, but this is not essential in wedding photography inasmuch as you will not stay in one place long, and the wires would also get in the way.

7. The unit should be marked as clearly as possible; even guide numbers should be readable. However, this is *not* essential as it is assumed you will get to know your equipment perfectly before photographing a job.

THE FOUR-BAG WAY OF SHOOTING A WEDDING

The reason for this setup is simple: In order to be able to photograph at all times, even the strongest photographer cannot carry all his or her equipment *and* take pictures at the same time. Large bags get in the way; small ones do not.

Why drag unnecessary equipment around (photofloods outdoors, for instance)? Why get cameras loaded with color and black-and-white film, respectively, mixed up when they can be kept in two separate bags? Why not have the right size bag that will hold your electronic flash mounted for action instead of having its parts scattered in a larger bag?

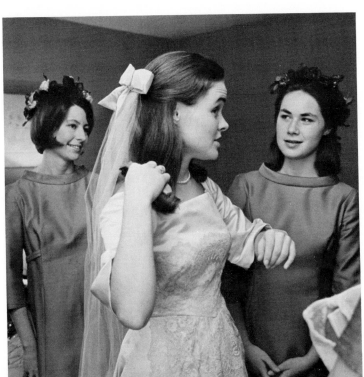

Bounced electronic flash in a room with medium-blue walls and light-blue ceiling at f/5.6.

All these problems can be solved in a most satisfactory way by having four bags always packed the same way, fulfulling their roles to perfection.

I would like to tell you exactly how I pack these four bags. You can always adapt some similar system to your own requirements.

Checklists

PACKING MY FOUR BAGS

No. 1
Camera bag

1 Minolta SLR camera with a 55mm lens.
1 Minolta SLR camera with a 100mm lens.
1 light rangefinder-type camera with a 35mm wide-angle lens.
These three focal lengths give me good coverage for nearly all situations.
This is the bag that always stays on my shoulder.

No. 2
Camera bag

1 Minolta SLR camera with a normal lens. It is usually loaded with color film.
6-8 rolls of extra film and a plastic bag to hold the exposed film. (This film supply is in addition to the 4-5 rolls I carry in a pouch on my belt, along with a marking pen.)

No. 3
Shoulder tote

1 Minolta Auto Electroflash 450 mounted on its bracket, ready for attaching a camera to it.
One 510-watt battery pack.
2-3 tripper cords.
Emergency flash unit with bulbs, preferably magazine type.
The rest of my extra film in a plastic bag.

No. 4
Lighting case

2 medium-size light stands.
3 socket fixtures with clamps.
3 extension cords, 12 – 15 feet each.
3-4 photoflood bulbs or quartz light bulbs.
If the speedlight battery is not new, a spare.

EQUIPMENT

Cameras
2 cameras if you shoot color only or black-and-white only.
3-4 cameras if you shoot both color and black-and-white.
Extra lenses, both telephoto and wide-angle.
Lens shades for all lenses.
Filters: light-yellow and skylight
Lens-cleaning equipment: blower, brush, tissue.

Film
At least 12 rolls of 35mm 36-exposure Tri-X.
6 rolls Plus-X.
6 rolls each of regular and high-speed color film.
(This is for coverage in both color and black-and-white.)
Felt-tip marking pen for noting unusual backgrounds, exceedingly high or low contrast.

Speedlight
Your unit, with bracket to mount camera on it.
Fresh batteries, or 1 set of replacement.
Tripper cords, at least 2 extras.
Tripper cord extensions, in case you mount speedlight on stand.
Either a second, smaller unit or a flash outfit with flashbulbs as insurance.

Photofloods
2 light stands.
3 socket fixtures with clamps.
3-4 reflector-flood bulbs or quartz lights.
3 extension cords, 12–15 feet each.
1 fifty-foot extension cord if you travel by car.
A good, regular flashlight.

QUESTIONS TO DISCUSS WITH YOUR CLIENT IN ADVANCE

Time-table of wedding
When will it start?
How long is it expected to last?
When does the bride want you to start photographing?
Where will the reception be held?
What will be served? Buffet, dinner, or refreshments only?
Will there be dancing?
When should the group photographs be taken?
Will limousines be used?

Permissions
What photographs are allowed in church?
Is there a balcony in the church?
How long is the ceremony?
Can you ride in the bride's car?
Can the family suggest someone to help you with unexpected problems and to point out important guests?

The photographs
Do your clients know exactly what kind of photographs they want?
What size?
Color *only*? or black-and-white *and* color, depending on your judgment?

Financial
Do your clients know your package price and exactly what you give them for it?
What do extra prints cost?
Any need to charge more because of longer time needed for travel or length of party?
How big an advance payment?

Technique CHAPTER 2

AVAILABLE LIGHT

The term "available light" has come to mean so many different things to people that I'd better start by defining what I mean when I use it.

To me, "available light" means just what it says: whatever light is available at the moment, whether strong or weak, indoors or out, *without supplementing it by any other light source.* It means walking around with nothing but your camera—no lighting equipment.

Available Light Outdoors. First, let's consider the available light that we encounter outdoors in wedding photography.

What I dread is a bright, sunny day. What I hope for is a cloudy or hazy day. The difference between the two is tremendous. When the sun is shining, I can never tell how it is going to strike the face of someone I want to photograph; for instance, the bride leaving the house may be in full sunshine, the father who is escorting her in full shadow. The garden ceremony on page 32 had to be shot exactly where the family had planned it, to conform with the topography of the garden and the convenience of the guests. The result: an unevenly lit, splotchy picture; and a flash would not have helped either.

In dealing with bright sunshine, you can do one of three things to influence the situation: If you let the sun shine directly on the faces of your subjects, they will squint. If the sun hits them from the side, one side of the face and clothes will be overexposed, the other normal. If the sun backlights the scene, this creates the most pleasing situation. But in that case, a fill-in would greatly enhance the picture, and we can no longer talk of "available light photography" (see section below on "Fill-In Lighting Outdoors").

Even in the shots where you cannot change the position of your subjects, you can still try to change your own to avoid direct sunlight on their faces. With the sun behind them, remember to tilt the camera lens slightly downward to avoid sun rays striking the lens. Even the sunshade doesn't give enough protection without this little trick. You must also make sure that the

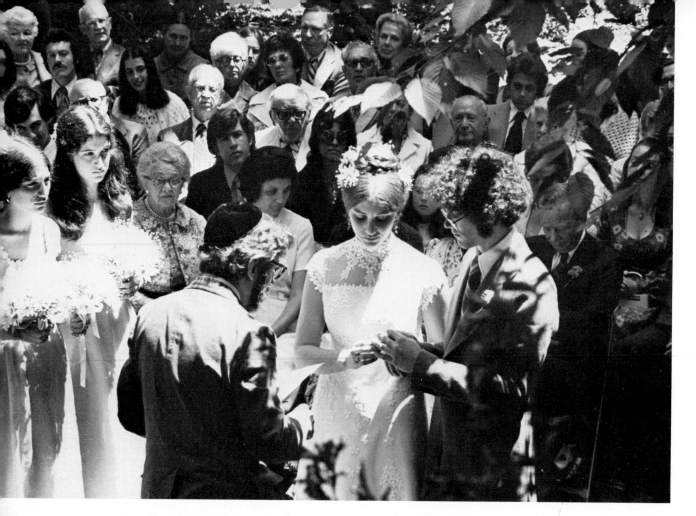

Sometimes we have to accept that not every situation can be improved. Only a change in the location of this outdoor wedding would have resulted in a better shot; no fill-in would have eliminated the blotchy sunlight without destroying both the overall look of the photograph and the solemn mood of the occasion. 100mm lens from far away, 1/125 sec. at f/11 on Kodak Plus-X Pan Film.

light meter is not fooled by the sunlight, which, in this situation, is lighting up the background more than your subjects. If in doubt, open up your lens one more stop than the meter says (see section on "Exposure Meters" pages 19, 21).

Fill-In Lighting Outdoors. Sunlight is easier to deal with when you can suggest locations—for portraits and group pictures, for example. Then you can pose your subjects with some reflecting surface in front of them, which will fill in the shadows. They can stand on the lawn with the sun behind them and a gravel or cement pavement in front of them; the photograph will be much easier to print than if the lawn were in front of them. If you can stand with the wall of the house at your back, it may serve as the perfect fill-in, especially if it is white or light-colored.

If you think that it is simpler to bring your own fill-in, you may be right. But what fill-in? Wedding photographers cannot even contemplate carrying reflectors as fashion photographers often do; photofloods can only

be used on the rarest occasions; so we are left with flash or speedlight as the most logical choice for fill-in.

Your basic aim in using fill-in lighting outdoors should be to lighten up darker areas without letting this supplementary light source overpower the general lighting of the subject or scene. Were you only to consider the exposure for your flash or speedlight, you would often lose the background and produce a highly artificial-looking picture; in some cases, the background

An example of direct flash used outdoors without taking into account what the late afternoon scene would have required as exposure. The result: nighttime atmosphere. Normal lens, f/11 from 12 feet away, Tri-X.

could go so dark that it would appear as if you had taken the picture at night instead of in daylight.

You cannot expect to have any success with fill-in lighting—be it flash or speedlight—without knowing how to use the guide number of your light source in arriving at the correct exposure. Luckily, you don't have to figure out the guide numbers yourself; they are clearly printed on each flashbulb package and given for each electronic flash, calculated for different ASA film speeds. As the duration of both flash and speedlight is constant and extremely short, you have only to consider the *f*/stop when trying to find the

Whenever there is room, I prefer to back away and use an 85mm or 100mm lens. I posed this group in open shade. Late afternoon, 1/125 sec. at f/8 on Plus-X.

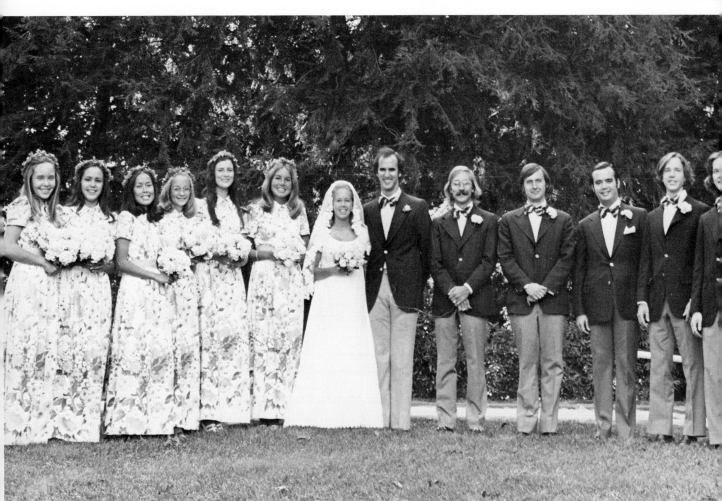

correct exposure. To do this, divide the guide number by the distance in feet from the light source to the subject. For example: a guide number of 80 for Kodak Ektachrome-X, ASA 64, divided by 10 feet gives you *f*/8. At the same distance, you get *f*/11 for Kodak Plus-X if rated at ASA 125; *f*/5.6 for Kodachrome II, ASA 32, and so on. If you cut the distance in half, you get *f*/16 for Ektachrome-X, *f*/22 for Plus-X, and *f*/11 for Kodachrome II. It works out to a two-stop difference in *f*/stop when you cut the distance in half.

But how can you tell whether these exposures fit in with the exposure needed for the general scene as regards to fill-in lighting? For simplicity's sake, assume for a moment that you are using a camera with a between-the-lens, or Compur-type, shutter, which will accept synchronization of flash or speedlight at all shutter speeds. Your light meter tells you that you should expose 1/125 sec. at *f*/16 on Plus-X film; that, of course, is the same as 1/250 sec. at *f*/8, or 1/60 sec. at *f*/22. All you have to do now is choose the exposure combination whose *f*/stop is the same as your guide number computation. If you prefer less fill-in, then double the *f*/stop of your guide number computation.

This very realistic computation also shows you why you should avoid the use of Tri-X film outdoors whenever possible: There aren't small enough lens openings on most cameras to match what the flash fill-in demands.

But what if your camera (your favorite focal-plane-shutter-equipped SLR, for instance) only synchronizes flash and speedlight at the maximum shutter speed of 1/60 sec.? That would require an *f*/stop for the overall scene which would be too small for your flash calculations; it would not give enough fill-in. Until more and more manufacturers correct this difficult situation and make focal-plane-shutter cameras that synchronize at all speeds, you can still produce fairly good pictures either by going closer to fill in, or by being content with less than the ideal 1:2 fill-in ratio, or by accepting some overexposure of the general scene.

If you are lucky enough to photograph a wedding on a hazy day, your life will be much simpler. The light will be soft and strong, without harsh shadows, and you can photograph everyone from any direction without changing the exposure. This is also true if you photograph late in the day in summer; there's about an hour after the sun's rays stop hitting directly when you can shoot easily by changing the film you usually use outdoors to faster film.

If there is a place where you can photograph groups in open shade on a sunny day, this lighting is a duplicate of the lovely late-day light. But even in this light, the direction in which you ask people to turn is important; it is desirable that the light from the sky provide frontal lighting for their faces.

35

You can find many examples of available-light photography throughout this book; here is one more, taken by the light of a regular table lamp.

You don't need to wait for a wedding or even carry a camera to investigate the possibilities and pitfalls of open-shade lighting. Just take a slow walk with another person in the shade of a building, under large trees, or wherever you find open shade, and observe how the light affects the modeling on your subject's face. Some angles will create rings under the eyes; others will put some light in the eyes. Choose the one that flatters your subject the most.

Available Light Indoors. If you could crystallize the difference between my approach and that of other photographers writing about wedding photography, it would be in our attitudes toward available-light photography. I am willing to take a chance on shooting most of my wedding pictures by available light or a semblance of it. I explain the advantages of available-light black-and-white photography to my clients, assuring them that I will use flash where necessary and will also take some shots in color. I always reserve one camera, loaded with Tri-X rated at ASA 800, for available-light photography. I enjoy the feeling I get when I can walk among the wedding guests with just a camera or two on my neck. And I always include some really candid shots among those I enlarge as a first submission to my clients.

My Minolta cameras with their built-in light meters make available-light photography a pleasure. I appreciate having a single-lens reflex camera that also has a rangefinder in the groundglass; after shooting hundreds of pictures, one's eyes can get tired, so split- or double-image matching is easier than judging relative sharpness in the groundglass. I also like seeing shutter-speed and *f*/stop numbers in the groundglass frame. My favorite lens for "sneaking" pictures is the 100mm *f*/2, which lets me keep at a distance from the people I am photographing.

I am glad that my speedlight failed to go off in this shot; now I have a good example of a situation where backlight bleaches out part of a picture and fill-in is definitely needed.

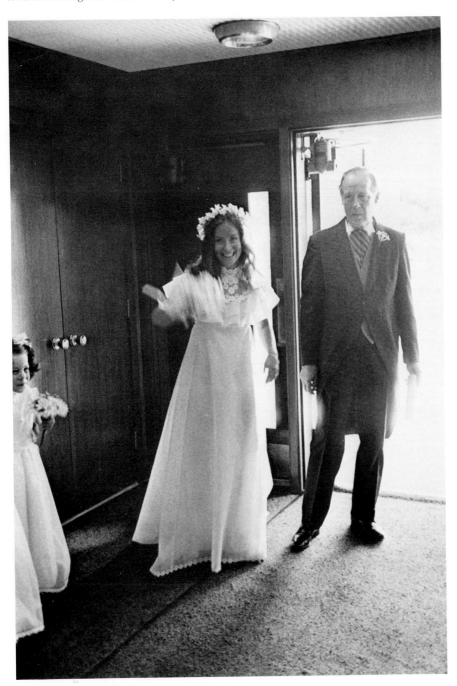

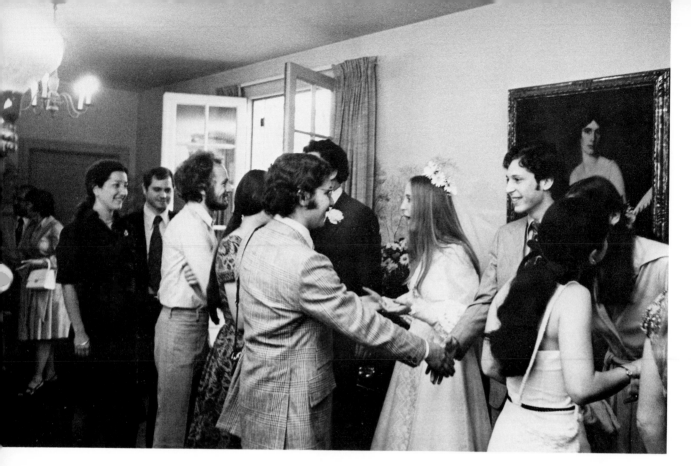

A photograph showing a photoflood on a stand near me, as it illuminates a room where the receiving line was coming through. Normal lens, 1/60 sec. at f/4, Tri-X.

Meanwhile, I am always watching the background. Wherever possible, I shoot light figures against a dark background and dark figures against a light background. If I see that the background is distracting, I open my lens wider so that my subject will appear sharp against an out-of-focus background.

I often risk exposures as long as 1/30 sec., as I believe that a little blur from subject movement will frequently enhance the activity of the scene. (This should not be confused with the fuzziness resulting from incorrect focusing!)

I don't consider myself the "director" of a wedding; I am just someone who records what is happening. But if I have the chance to ask people whether it matters to them in which direction they will line up for the receiving line, for instance, and they say it is immaterial to them, then I make sure to suggest a place that will permit me to use the existing light to its fullest.

PHOTOFLOODS

I use photofloods at the bride's house and sometimes at the reception in the following ways: (1) as the main light, bounced; (2) to augment existing light,

bounced; and (3) as the main light, direct. Let's examine each of these situations.

Photofloods as Bounced Main Light. When I find myself in an average-size room with a light-colored ceiling and/or walls, even using only one photoflood bounced from ceiling or wall will allow me to shoot at 1/60 sec. at *f*/4, rating Tri-X film at ASA 800 (which I consider its normal speed). I am very careful to set up the lights so that they don't get in anyone's way; I can hardly expect an excited bride to remember that she should step over my wires! So I hide them under rugs, run them around the edge of the room, even tape them to furniture if necessary. After a minute or so, my subjects will have gotten used to the increased light, and I can photograph with greater freedom than flash or speedlights permit. I also have the opportunity to change the lighting setup if I notice that my lights throw unexpected shadows or fail to emphasize the most important people in the group. I especially prefer to shoot into a mirror when I can see exactly what the finished picture will look like.

Bounced Photofloods Augmenting Existing Light. At weddings where the ceremony and reception are held in the home, and I don't have to light up more than a large room with an average ceiling, I nearly always use photofloods. Two lights placed well out of sight of the camera can make the photography of scenes like toast-making and cake-cutting much easier. My lights also help the guests to see what is going on. This seems to add to the festivities, while popping flashes irritate many people. Bounced photofloods

The bounced photoflood I had clamped to a bookshelf helped to show up the beauty of this exquisite spring bouquet. 1/30 sec. at f/4, Tri-X.

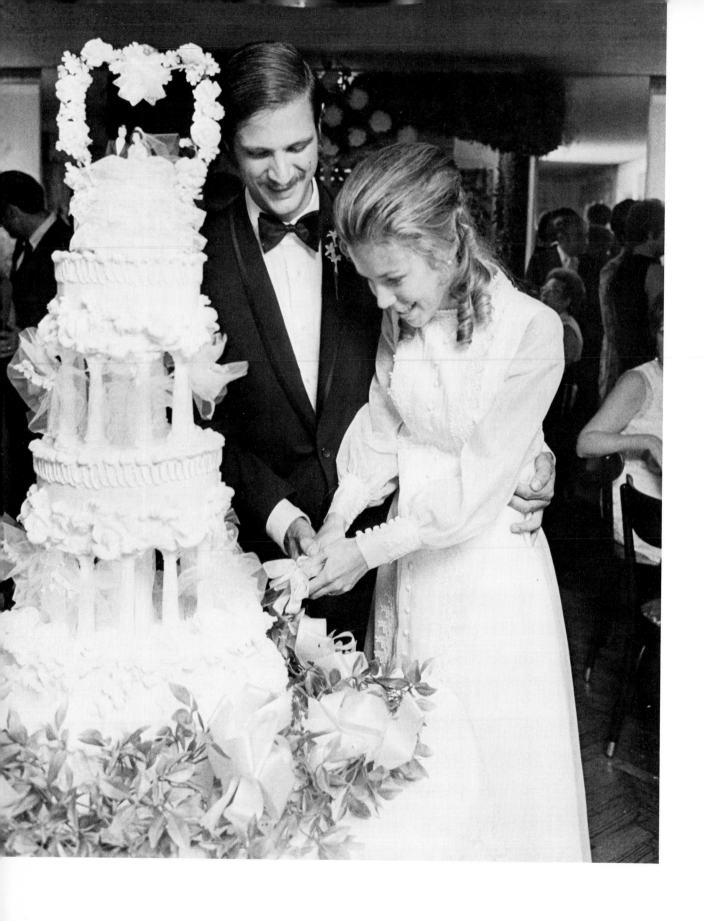

mix beautifully with existing light of all sorts—but only in black-and-white photography. In color, you can use tungsten-type film and photofloods only when there is no daylight. Only blue flashbulbs or electronic flash go well with daylight in color photography.

Photofloods as Direct Main Light. Photofloods used directly (versus bounced) are most useful for bridal portraits and group portraits; in other situations they get in the way. My two favorite setups are illustrated below.

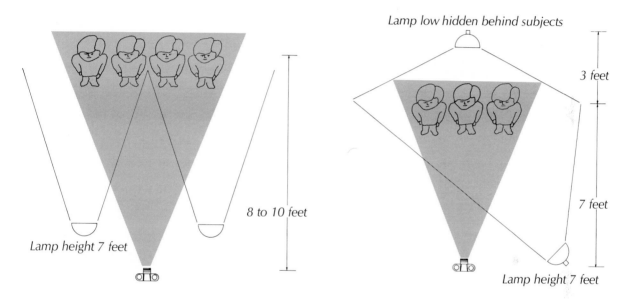

FLASH AND STROBE

Wedding photography taught me how invaluable flash or electronic flash really is. Until then, I kept telling myself that children were too easily distracted by the intermittent flash of light; that in adult portraiture, it was too important to really see what I was going to get in order to make my subjects look their best; and on a picture story, available-light photography gave me the atmosphere that really existed, instead of having it completely changed by flash. So I carried a small electronic flash as insurance, nothing more, and relied on boosting available light with a bounced photoflood.

I hate to think what direct floods or flash would have done to this picture. The cake would have been overexposed, and shadows would have marred the figures. Two bounced photofloods, 1/60 sec. at f/5.6, Tri-X.

41

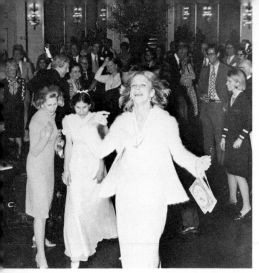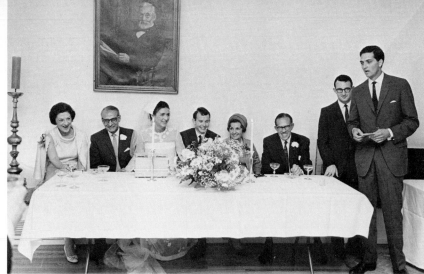

Left: A situation made to order for direct flash or speedlight; nothing else could have worked. I printed-in the front figures, which received more exposure than the general scene. Normal lens, f/8. Right: My Minolta Auto Electroflash 450 at its best, giving perfect exposure in a bounce situation (an extra sensor takes care of that). My only regret: that the intimate candlelit atmosphere was changed completely by the powerful light. But, as they say, you can't have everything.

DIRECT FLASH

I started photographing weddings as though I was covering the event for *Life* magazine, and brought all my prejudices against flash with me. I still shoot a lot by available light, and never go anywhere without one or two photofloods, but necessity has taught me that a wedding coverage *needs* flash pictures. An early wedding with an outdoor reception obviously won't need flash more than in a few situations, but suppose the wedding is late in the afternoon, followed by an indoor reception and dance? Most of the photographs will have to be taken with speedlight or flash. If you are lucky, you will be able to bounce most of them; but as a wedding photographer, you will encounter many large, dark rooms and halls, and then nothing will save the day but knowing how to shoot direct flash.

What is there to know? someone who started photography with a small, inexpensive camera and flashcubes might ask. Well, there are ways to improve this simple procedure.

You can, for instance, develop a very good sense of distance and get used to adjusting your f/stop as you move closer to or farther from your subject. The difference between a portrait taken from 5 feet away and a group shot taken from 10 feet may look like a one-stop difference, but from experience, I'd say it is closer to two stops for some reason. So take many tests, with shot-by-shot notes and other data. They are invaluable until you really learn to estimate f/stop settings, or until you get an automatic speed-light.

When I first started to use my Minolta Auto Electroflash 450, I was very suspicious, and mixed my automatic tests with manually set, carefully

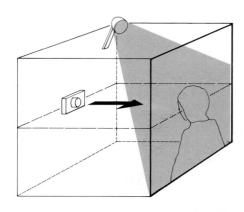

One way to improve direct-flash pictures is to separate the flash unit from the camera and hold it higher and to one side of the camera, as shown here.

noted *f*/stops. When I saw the developed film, I could tell what the automatic brain was doing; why, it was duplicating my good old *f*/11 for Tri-X perfectly! But joking aside, it *is* nice to let the speedlight set its own time. It lets you choose your *f*/stop according to what depth of field you prefer (within a certain marked limit) and then controls the length of time the flash will last. And because I'm speaking of speeds of 1/500 sec. to 1/10,000 sec., you can see that it is a most impressive modern achievement, and undoubtedly the wave of the future.

Another way to improve direct-flash pictures is by separating the flash attachment from the camera and holding it higher and to one side of the camera. (Always let the flash come from in front of a person, not from the back, if his or her head is in profile or three-quarter view.)

Another important trick: Take your pictures as far away as possible from the wall or other background, then the shadows will be much less apparent.

FLASH METERS

If you want to skip some of the time that it takes to acquire experience, renting an electronic flash meter could be a good investment. It is an amazingly accurate and simple tool, and will give you the exact exposure whether you shoot one flash or many, direct or bounced. One day's test, with good notes, should really make you an expert fast.

BOUNCED FLASH

You will find that, depending on the height and color of ceiling and walls, bounced flash will require an *f*/stop that is two or three times wider than if you shot direct flash. For example, if your camera setting is *f*/8 or *f*/11 for direct flash, it will have to be *f*/4 for bounced flash. I am lucky in that my automatic electronic flash adjusts to bounce situations with a separate sensor, so I can go from direct to bounce with a small adjustment of the bracket. More and more companies produce such equipment these days.

Bridal Portraits CHAPTER 3

Before talking about bridal portraits, let me show you some pictures that led to my first such job. Here is Wendy in a photograph I took when she was seven years old; then the portrait she asked me to take for the papers when she got engaged 12 years later; and, finally, one of her bridal portraits.

 I am always very careful when I photograph an engagement picture. Though the papers only want a simple, straightforward head shot against a light background, and this is not hard to do, I consider this opportunity a chance to show my work and what kind of contact I can create between myself and the bride-to-be. I doubt that I would end up with the wedding coverage if my clients were disappointed with the engagement picture, or if they found me personally hard to work with.

Wendy, at age seven, and again at twenty-one, when she asked me to take her engagement picture; finally, as a bride a few months later (the picture at the right was taken during the last fitting of her wedding gown). In the first photo, a bounced flood was used; in the second, two direct floods—one on the background, the other on Wendy's face from the front; in the third, two direct floods, back and front of Wendy.

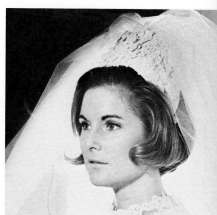

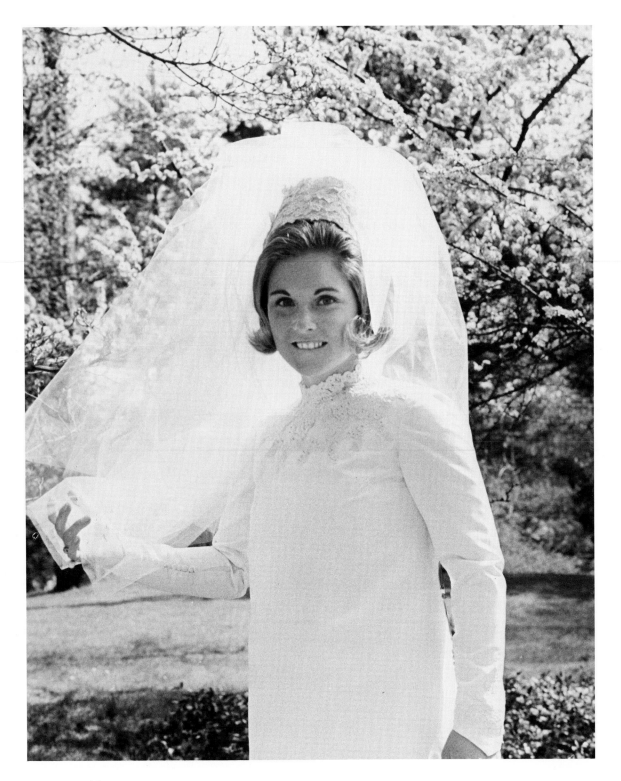

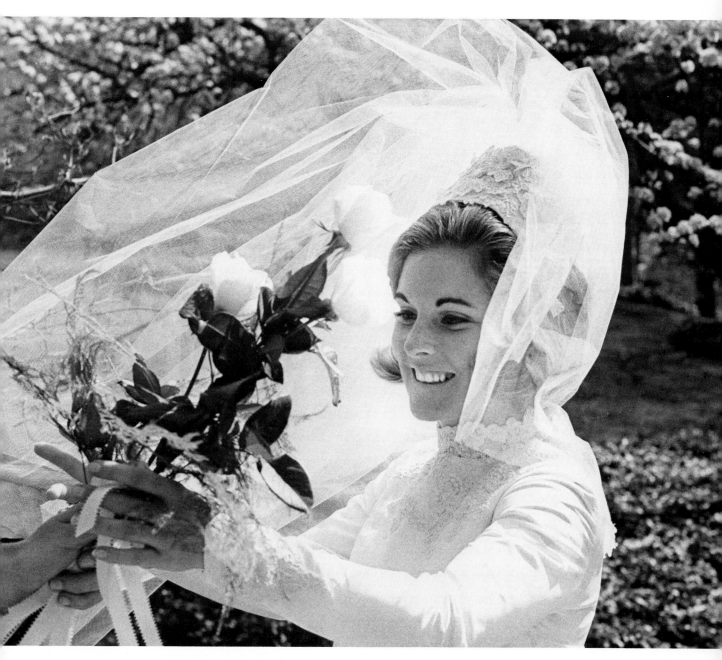

Wendy on her wedding day. First, as she started to pose in their Connecticut garden, full of blooming apple trees, a few minutes before going to church. The second picture has some added magic; the spontaneity of the action, a gust of wind, and my alertness in not letting this moment pass, created something unusual and beautiful. Weak sunlight, no fill-in; 1/250 sec. at f/8, Plus-X rated at ASA 200 and developed in a mixture of one-half Kodak Developer D-76 and one-half water to cut down contrast further.

47

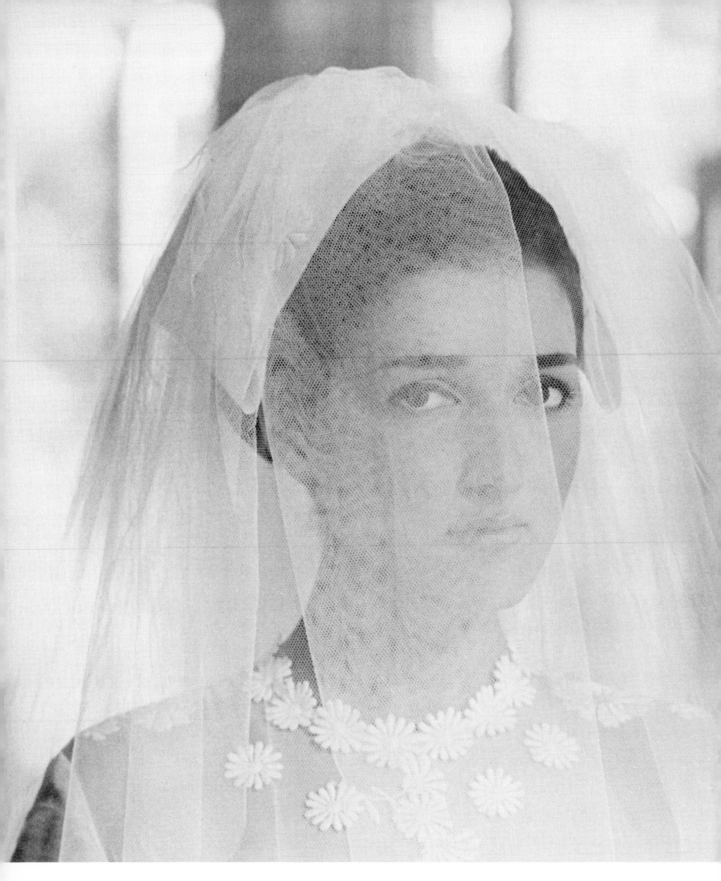

FORMAL BRIDAL PORTRAIT

As for the formal bridal portrait, there are two occasions when you can take it: some time prior to the wedding, and on the wedding day. The first will occur several weeks before the wedding, usually at the time the wedding gown is ready or at least ready to be photographed at a fitting. The portrait is taken for the newspapers, to be published on the day of the wedding, and newspaper deadlines run from one to four weeks.

I am usually asked to go to the department store or specialty shop where the wedding gown is being made, to take the picture on their premises. This is not the easiest of assignments. Hardly ever is there sufficient available daylight to work with; what is worse, the cramped fitting rooms often have mirrors on three or even four sides of their walls, so the photographer has the hardest time hiding his or her own image. And most of the time, you must avoid showing last-minute pinnings and newly basted seams.

Luckily, newspapers only use black-and-white, and usually prefer head-and-shoulders shots to full-length pictures. So I can leave color and full-length photographs for the day of the wedding and concentrate on this head-and-shoulders portrait.

There is one factor that works for me despite all the difficulties: that is, it is here, at this moment, that most brides see themselves for the first time all dressed up, complete with veil. Unless the bride-to-be happens to be upset about the way the dress has turned out (and it can happen!), she will have a special, delighted smile on her face. My job is to intensify this feeling by being happy with her, by praising what I really like, and by keeping my difficulties about the photography to myself.

Shooting Techniques. I always start to take pictures without giving any directions; I let the bride stand the way she wishes, hold her hands as she wishes, smile or be serious as she wishes. Usually, she is a hundred times more interesting in her own positions than if I posed all brides the same way. Technical perfection should not be attained at the cost of artificiality. Excessive posing also makes the subject feel like a "thing" instead of a person. If there is something to correct in the pose, I wait to see whether the bride will do so spontaneously; if not, then I start suggesting different ways to hold her hand and place her weight. But all the while, I am taking pictures, perfect or not, and many times the choice has fallen on one of the first shots, not the supposedly improved later ones.

Perhaps my favorite bridal portrait, taken by available light in a fairly dim synagogue. Every time I look at it, I feel touched by Lynn's beautiful, mysterious expression. 135mm lens on my Minolta camera, 1/60 sec. at f/2.8, Tri-X rated at ASA 800.

Left: A bridal portrait taken in an elegant department store. The scene was lit by one bounced photoflood near me and one aimed directly at the background. I was careful to calculate the exposure needed for her face and not the bright background. Normal lens, 1/60 sec. at f/4, Tri-X. Below: While I was trying to figure out how to avoid the multiple images created by the mirrors on three walls of a dressing room, I noticed that in one corner a double image looked quite interesting. Bounced floods, 1/60 sec. at f/8, Tri-X.

It helps both of us to talk about something pleasant. I feel that however well-meaning and justified my corrections may be, they should wait until the bride has had the chance to enjoy this unique moment and act out the way she herself wants to be shown. Nothing makes a woman look better than when she is being admired! So even if you don't agree with my philosophy of allowing the brides you photograph to be themselves, business sense should convince you. If they look most beautiful while natural and feeling good, and if people buy pictures in which they look good, and if you like selling them pictures, you see why you should follow my advice and stop forcing all brides into the same poses.

I start this picture-taking session by using two photofloods on stands, placed at about six feet from the bride, and bouncing them from the ceiling and/or walls. I slowly move the lights closer, watching all the time whether they flatter my subject. Wedding dresses are tricky to photograph. In the beginning, I used to backlight the filmy materials from a close distance, creating a beautiful halo but difficult printing problems for myself. Nowadays, even when I turn my two photofloods directly on my subject—as I am apt to do for the last dozen exposures—I keep both the back- and the frontlight sufficiently far away so that I get a balanced negative.

Photographing a suntanned bride also creates problems. If you expose and print for her face, there will be no detail in the dress; but if you favor the dress, the face will go too dark. There is a trick that can help in this situation: Use a yellow filter, which will lighten the face without affecting the dress. (This applies to black-and-white photography only; I have yet to find a comparable trick for color photography, unless the bride is willing to put on lighter makeup.)

Even if I succeeded in taking a bridal portrait at this session, which pleased everyone, I always try for another one on the day of the wedding. There may be less time and patience for posing, but I like to catch the excitement of the day. The best moment usually comes when the bride has just finished dressing and her mother and attendants see her for the first time. Earlier in the day, I set up one or two photofloods in the room in which this scene will take place, and so the room is already well lit. Then I follow the bride wherever she goes—showing her gown to her father; waiting for the car to go to the ceremony; in the car. I try everywhere for the one magical portrait, equipped with a 100mm telephoto lens.

One of the few bridal portraits I have taken at my studio. A very difficult shot, as the bride had a deep suntan, and her gown was white, of course. A yellow filter cut this contrast somewhat. Three direct photofloods, 1/125 sec. at f/5.6, Plus-X rated at ASA 200.

54

Left: I caught this bride while she was waiting outdoors in the shade of a doorway. 100mm lens, 1/125 sec. at f/5.6, Plus-X. Below: Full-length portrait of one of the brides shown earlier, however this one was taken just before she left for the church on her wedding day. Available light boosted by one photoflood, 1/60 sec. at f/4.

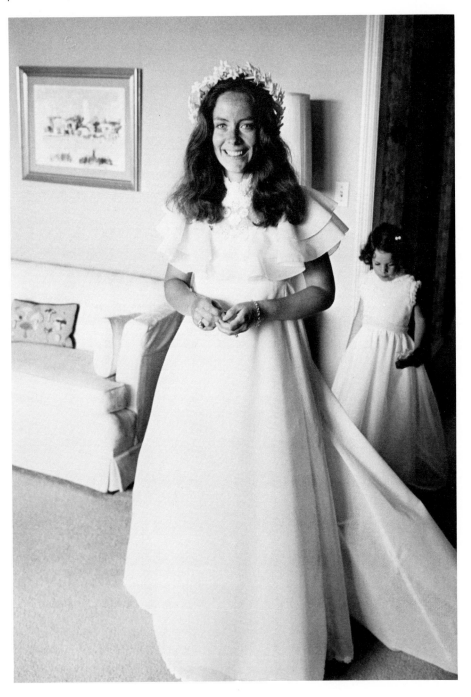

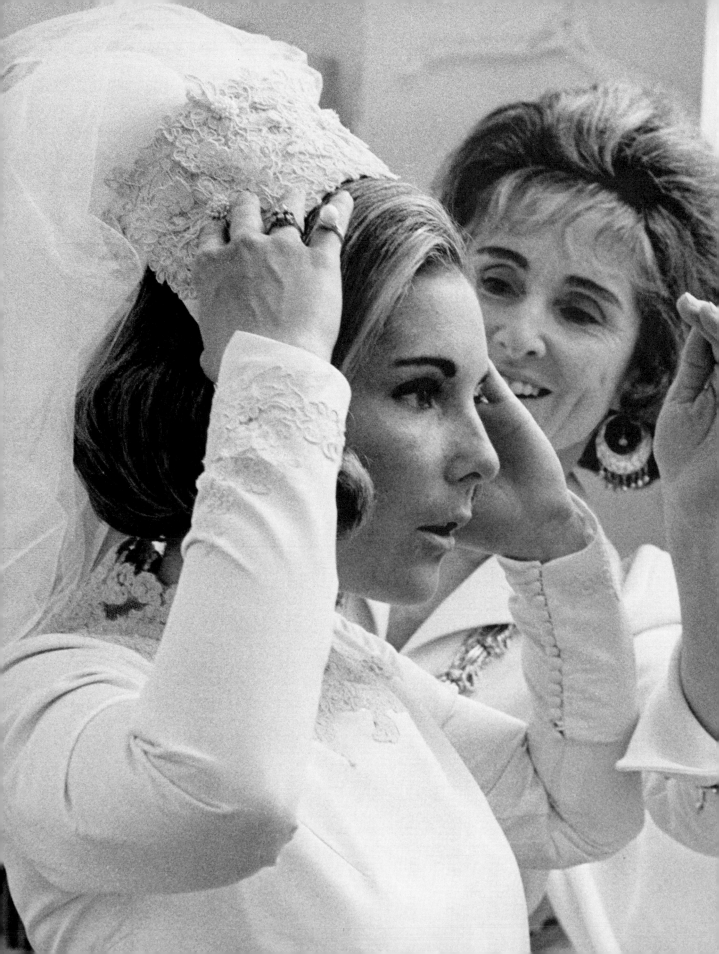

A Wedding Album CHAPTER 4

Here is a pictorial record of the very first wedding I ever photographed. I have already shown on page 45 how Wendy looked at age seven, when I met her, and later, at the time I took her formal engagement and bridal photos. Following are the candid shots, starting with the bride and bridesmaids getting dressed at her home, through the church wedding, club reception, dance, and bouquet throwing, to the hectic "going away" scene by waning daylight. It was all very new to me, and I worked doubly hard to be sure and catch every scene, every reunion of old friends, to get portraits of beaming people looking their best at this festive occasion, to depict all the emotions and funny moments too.

If some of the faces in the bridal group look familiar to you, that's because two of the bridesmaids later asked me to photograph *their* weddings; their pictures can also be found throughout this book.

By treating me with such friendship and cooperation on this occasion, the Warner family really caused me to enjoy wedding photography, and I thank them for it.

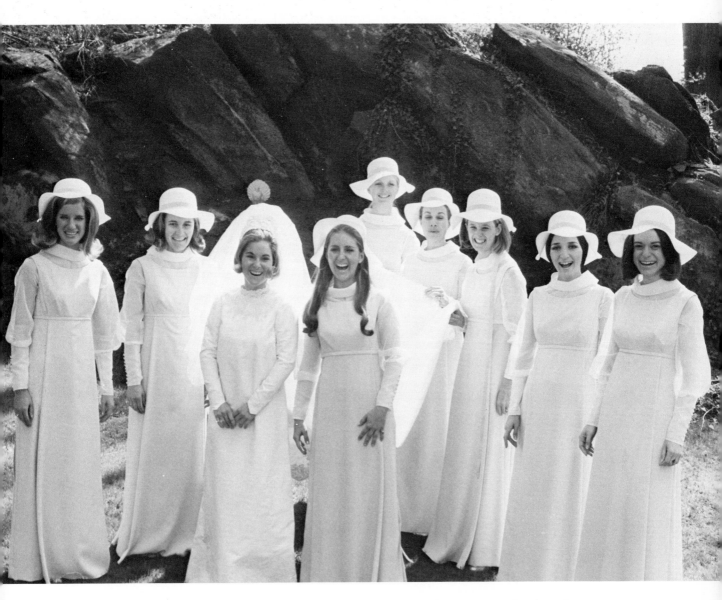

Left: In order to be able to shoot continuously and unobtrusively, I had set up photofloods in the bride's room, and caught many charming scenes. I am especially fond of the picture of this bridesmaid, pensively holding her rose. All these photographs were taken with a Minolta and a normal lens on Tri-X film rated at ASA 800. Above: I found an ideal spot in the bride's garden for taking some group shots before the wedding: a stretch of lawn in front of shaded rocks, with a cement terrace between me and the group. I had beautiful backlight and a natural fill-in. By opening my lens one stop more than the light meter indicated, I was able to get both the faces and the clothes in all their detail. As we had very little time, I had asked for some help in getting the group into a pleasant state of mind. So the bride's little brother stood on a chair near me and made faces at them. (Had he stood on the ground, everyone would have looked down at him—not a good angle.)

59

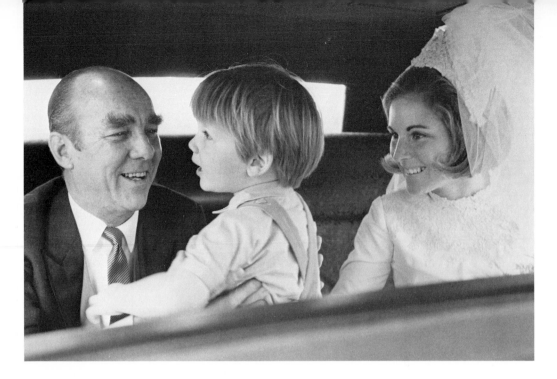

Riding in the front seat of the hired limousine and waiting for a fairly well-lit stretch of road, I took several nice pictures of Wendy and her father on their way to church. Little brother wanted to ride with them and had to be persuaded to go with his mother in another car, partly to maintain wedding custom, and partly to keep the bride's dress from getting wrinkled.

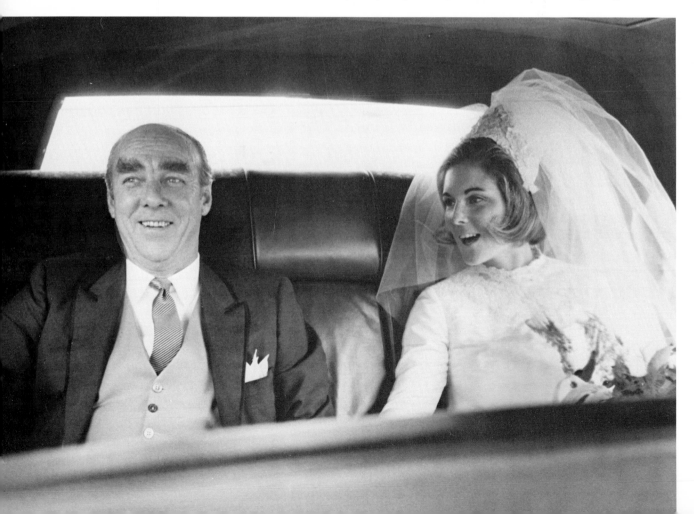

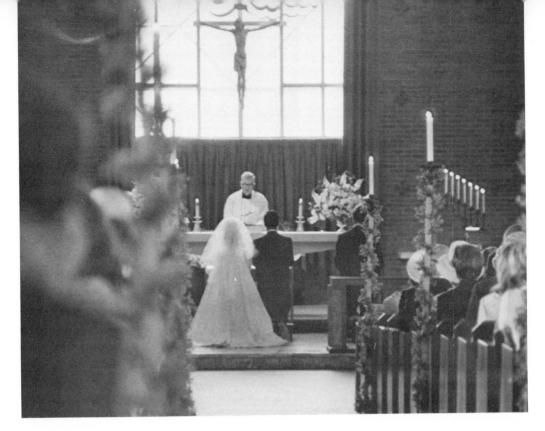

We had agreed in advance that I was not going to use flash during the ceremony; so I supported my camera on the back of a pew and quietly took a few shots at 1/8 sec. and 1/4 sec. After taking their vows, the couple had to pass a well-lit spot on their way out; so I prefocused one of my cameras, shot one picture at 1/125 sec. at f/4, then walked backward a few steps and took another shot with a different camera and flash. I prefer this one.

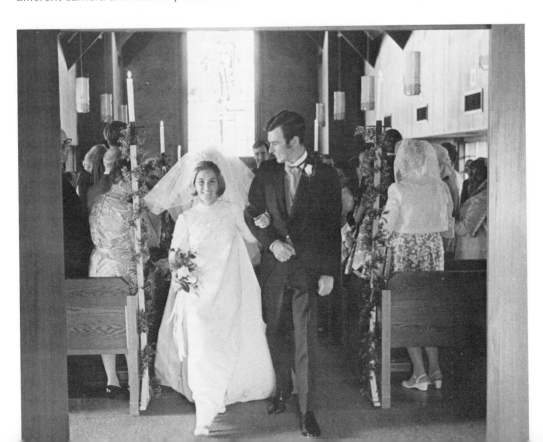

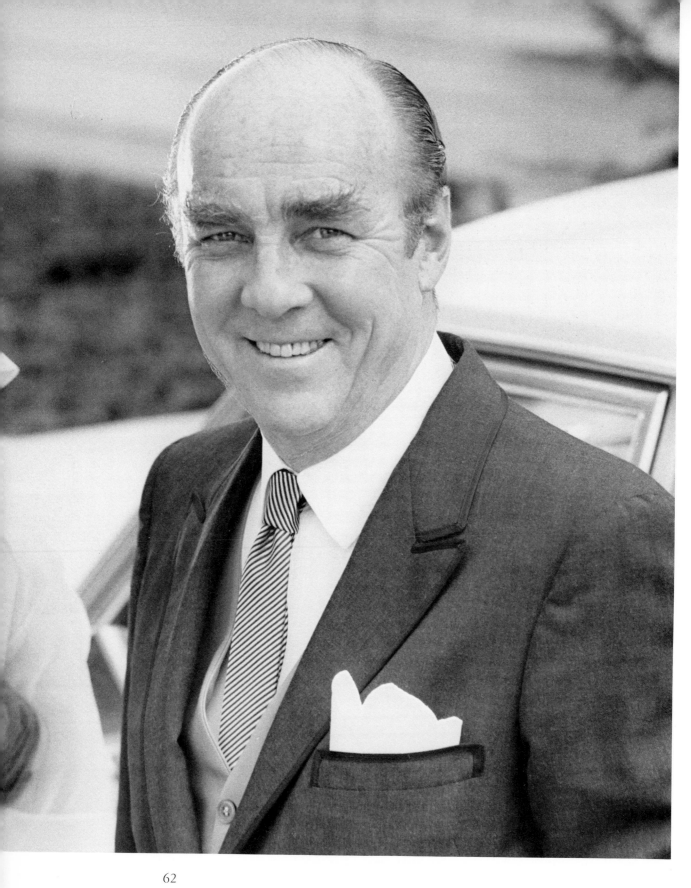

The wedding party was going to ride together to a club reception. While waiting for the cars to fill up, I noticed the bride's father standing near one of the cars, beaming. I caught him with a 100mm lens (left). He liked this picture so much that after cropping it as indicated, he used it as an "official" portrait. Below: When I saw the newlyweds kissing in their car, I took this picture through a lowered side window. I made sure that my built-in light meter really measured the light inside the car and that it was not fooled by all the surrounding daylight. 1/60 sec. at f/4, Plus-X rated at ASA 200.

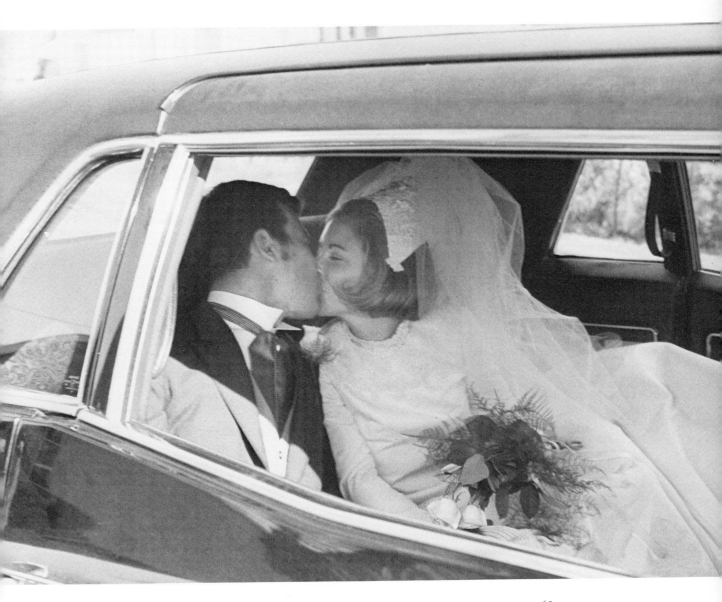

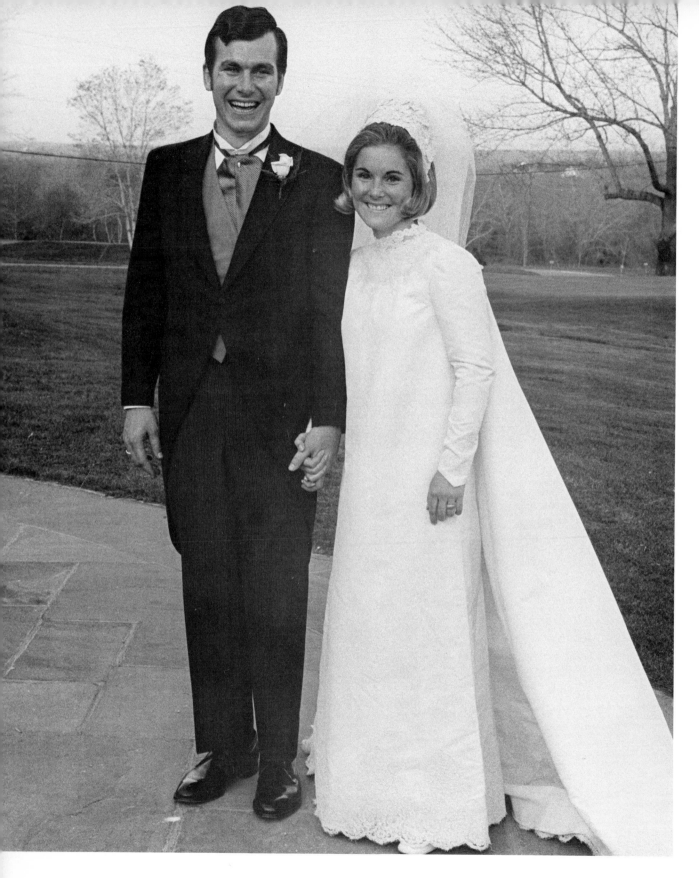

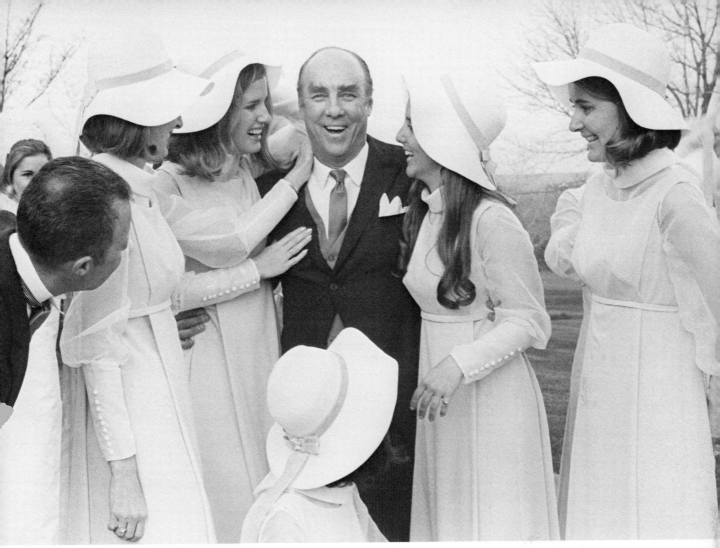

After getting out of the car with the bride and groom at the club, it took me only a minute or two to take some shots of them alone (left). As more people arrived, little groups formed on the terrace before going inside for the receiving line and party. Here is the bride's father (above), surrounded by a bevy of pretty bridesmaids. The weather was ideal: The sun had gone down, but there was still plenty of light to shoot comfortably on Plus-X rated at ASA 200, with most exposures 1/125 sec. at f/5.6. Wherever I looked, I noticed shots I wanted to take, and in this even, soft light, I was able to turn in any direction and do so. The bride's sister, a bit tense before and during the wedding, now relaxed and had a wonderful time (right).

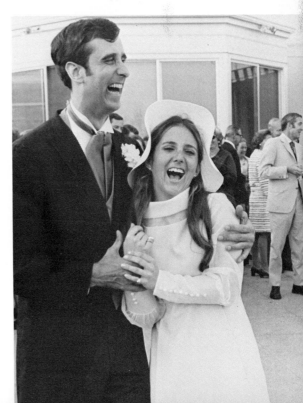

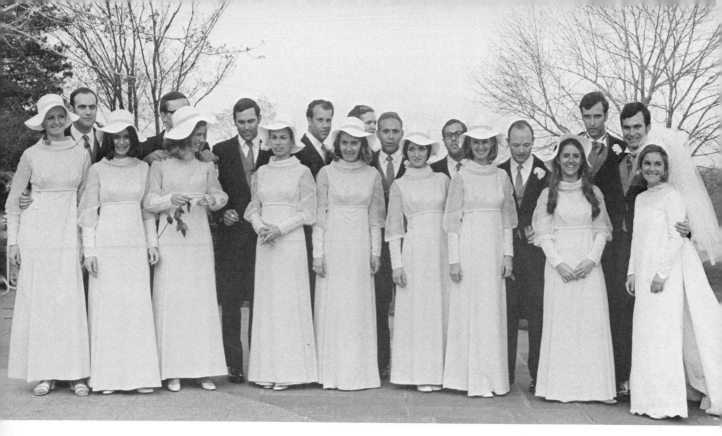

Then came the time to pose the whole wedding group. By the time the last participant arrived, I only had a few minutes before the reception started. I had not yet learned a small trick I was to use later: to tell everyone that they must be able to see the camera if the camera is going to see them. So I admit that this picture could have been improved upon, but at least I avoided dampening the spirits of this gay wedding party by badgering them and insisting on perfection. *Right:* The bride's parents at an intimate moment.

66

Below: This was an easy receiving line to photograph from all sides by available light. After shooting the principal participants for a while, I wandered around and came upon this interesting scene: the bride's loving but insistent hands on her husband's waist, possibly giving him some signal that someone whom he should recognize was approaching. Left: Then the dancing began, and I turned to my speedlight. Luckily, I was able to bounce it, because the ceiling was white and low.

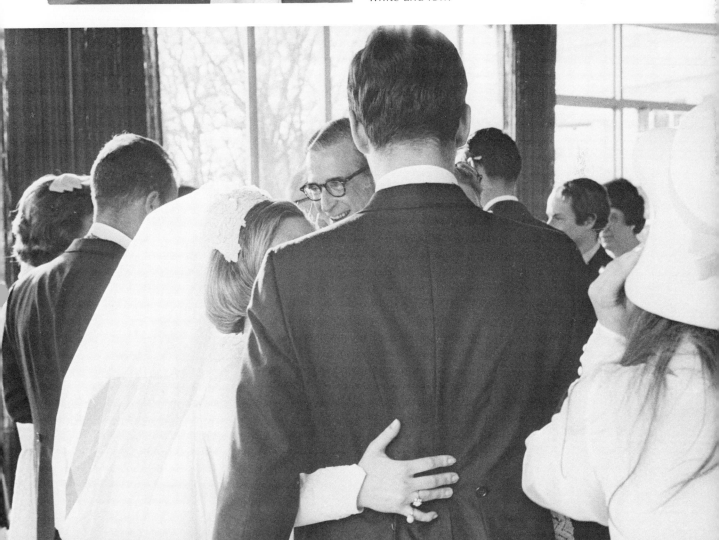

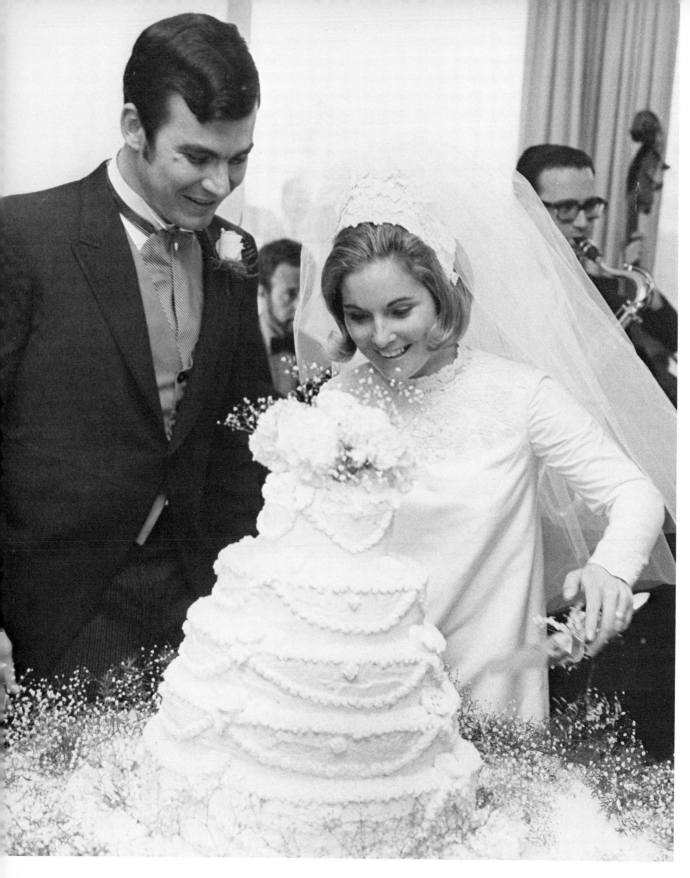

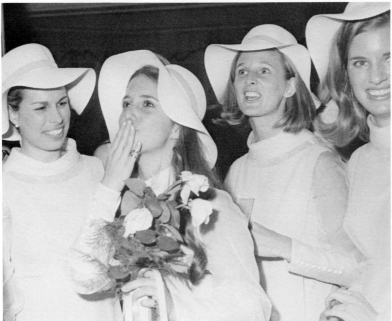

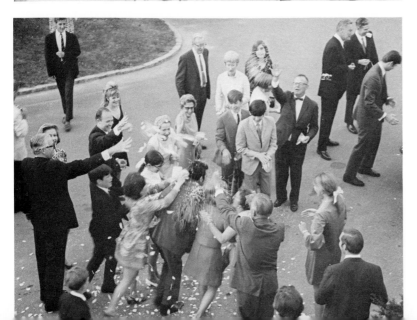

Opposite page: I really dislike using direct flash for the traditional cake-cutting scene; the cake is likely to be overexposed, and shadows may mar the figures. Here, I was able to use bounced speedlight, which eliminates such pitfalls. Left: I did not dare wait until the bouquet was actually in the air before taking this shot with my speedlight; after all, I also wanted to show who caught it immediately afterward—in this case, the bride's sister (center). At that time, I was still using a Mighty Light speedlight, with a recycling time of five to six seconds, so this worry was not unrealistic. (Nowadays, I use a Minolta Auto Electroflash 450 and a 510 battery pack, with a recycling time of three seconds.)

By the time the couple had changed into street clothes and was ready to "go away" ("running" would be a better word), it was nearly dark. Luckily, earlier on I had spotted the couple's getaway car being decorated by some pranksters, so I knew where to take up position. I caught them racing to their car and being pelted with rice and rose petals, while I stood at a first-floor window. From this high position, my exposure of 1/30 sec. at f/2.8 was sufficient; the blur adds to the scene.

I don't remember when I was more exhausted after a photo job than after "my" first wedding, but I could hardly wait to develop the ten rolls of 36-exposure 35mm film that I had taken. Evidently, I liked the results, because I went on to shoot many more weddings, using this as a sample album.

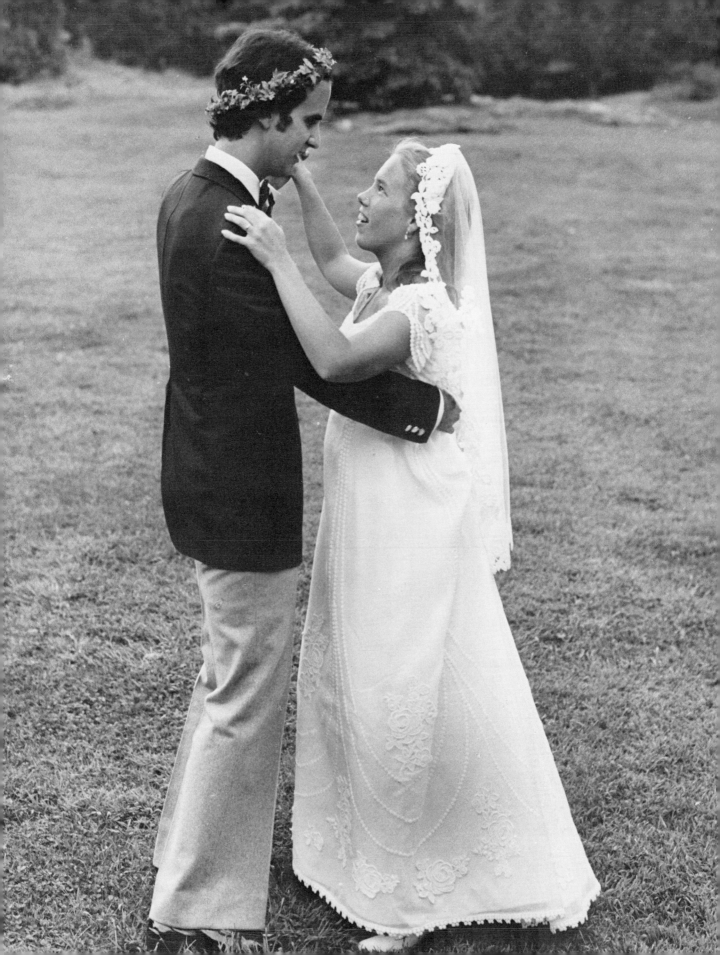

Color Photography CHAPTER 5

It would be hypocritical for me to say that all the photographs shown in this book in black-and-white could just as easily have been taken in color. I wish that color film had the same speed and exposure latitude as black-and-white film, but that is not so today. True, Kodak High Speed Ektachrome, for instance, can be pushed to ASA 320 by special development, but the chance for unnatural-looking color and excessive grain make this a risky proposition.

I have never met a photographer who would be willing to use this technique for the whole wedding. But I have seen too many who have given up on creating even a semblance of existing natural light in their wedding coverage, relying solely on their tried-and-true direct-flash color method.

If that is what you want to do, it is relatively easy to learn. Manufacturers' guide numbers for different films and flash units will give you a combination that you can always use and be safe—if a little boring. But if you want to capture reality in color and exploit its full potential, you will have to work harder and also take some risks.

COLOR FILM

Color film is realistic: It reacts strongly to changes in the quality of light. For instance, if the light isn't truly white but bluish, as in open shade, or golden, as in late-day sunshine, the color your photographs will show will be bluish or golden. Lenses are more perceptive than the human eye, but we reject these results as unrealistic, however true.

Another important difference is the amount of contrast that color and black-and-white film can handle successfully. The contrast range of color film is much more limited than that of black-and-white. A light ratio of 1:3 is pleasant in color photography, and 1:5 is about as much as a person's eyes will accept; black-and-white film, however, can render contrasts as high as 1:20. As an example, let's take the flesh color of a face, half lit by sunshine, half in shade. In black-and-white, this is tolerable and can be corrected some-

what in the printing process. But in color, our eyes reject seeing one side of the face appear light pink, and the other side a deep brown. Moreover, you can do nothing in printing to change this. Because of the lack of latitude in color film, it is also harder to avoid errors in exposure. I invariably bracket the exposures of important shots by one stop in both directions.

Backgrounds and Foregrounds. Equally important is the potential influence of background and foreground on the overall color cast of your photographs. I shall never forget one of my biggest goofs: I posed a large wedding party on a lawn, asking the members to line up near the edge of a swimming pool. I thought that the water would prove to be a better reflecting surface than the lawn. It certainly was, but the pool, like most pools, had been painted a vivid blue. As a result, all the faces in the pictures were suffused with a blue hue. I was certainly glad that I had also taken some black-and-white shots of the group.

Wedding gowns being white, they are especially likely to pick up whatever color surrounds them. The effect of reflected colors from light source and surroundings has ruined many a perfectly exposed wedding photograph—something you don't have to worry about in black-and-white photography.

COLOR PHOTOGRAPHY VERSUS BLACK-AND-WHITE PHOTOGRAPHY

So we have the interesting situation in which color photography is both easier and harder than black-and-white. Easier because in color photography, you get what you see (let's forget about the problems we just discussed for the moment). A brown dog lying in green grass will be clearly visible in a color photograph, but he could practically disappear in black-and-white photography, where a certain shade of green and light-brown both look light-gray. In black-and-white photography, you have to work with the contrast of light and dark that translates colors into the different shades of the gray scale. For most people, this takes quite a bit of experience, and so they take better color photographs in the beginning than black-and-white.

On the other hand, color photography is harder because everything has to be just right to reproduce the same shades of color in the photographs as you saw in real life; therefore, in color photography, technical knowledge, taste, and luck have to combine to produce really beautiful color photographs.

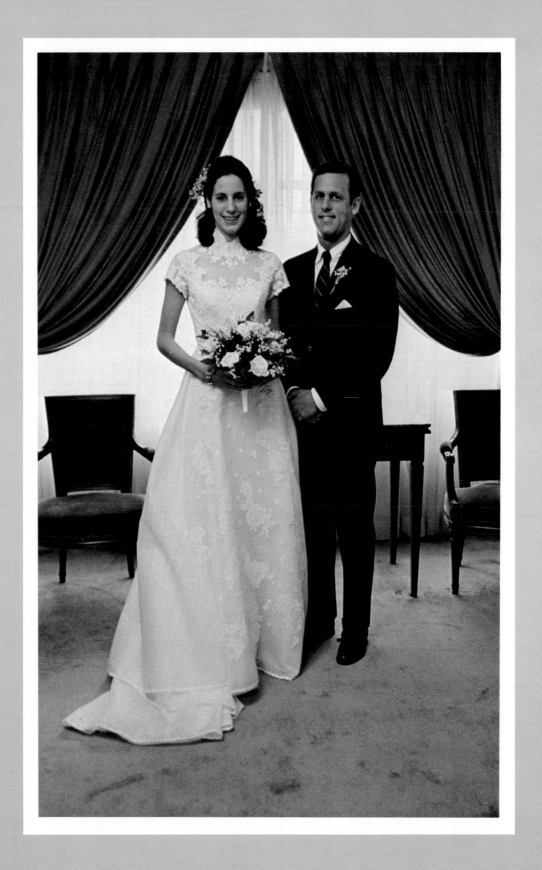

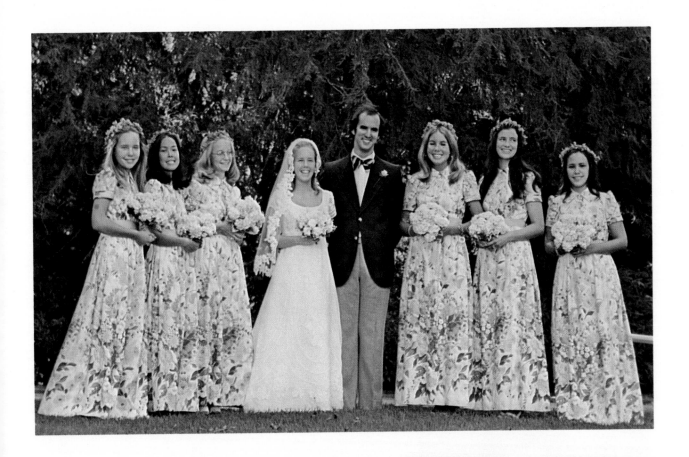

Above: A skylight filter warmed the tone of this group picture taken in the shade. To avoid distortion, I never use a wide-angle lens for group shots; if space permits, I use a 100mm telephoto lens, as I did in this photograph. 1/125 sec. at f/5.6, Ektachrome-X. Right: Flowers greeted guests at the entrance to this bride's house, where the outdoor ceremony was held. Normal lens, 1/60 sec. at f/4, Ektachrome-X.

Left: The most difficult picture to take: a formal shot of the bride and groom. There just never seems to be the time for it. According to most customs, the bride and groom should not see each other right before the ceremony; and afterward, they are excitedly trying to talk to all the wedding guests. This couple posed in a room with an eight-foot white ceiling. Two bounced photofloods, 1/60 sec. at f/4, High Speed Ektachrome (Tungsten).

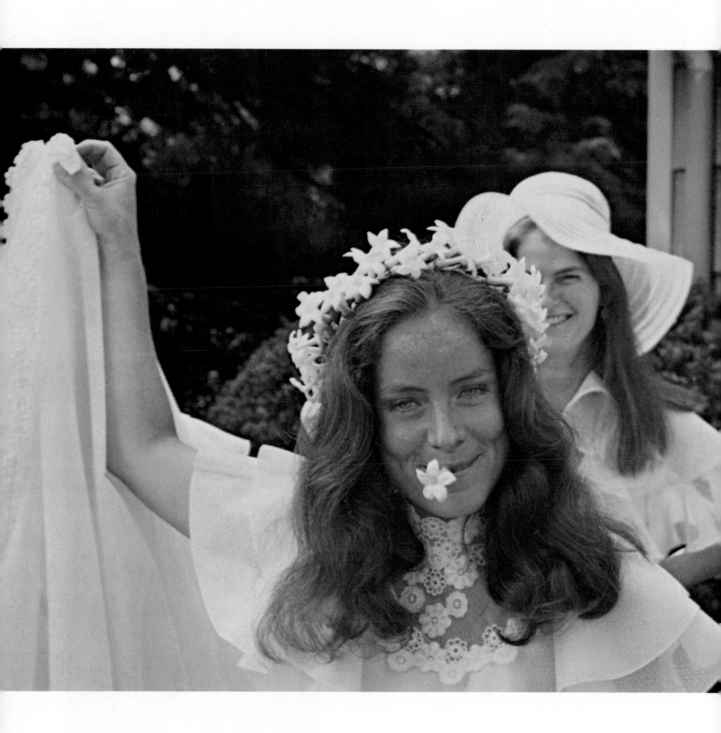

Using negative color film is the most convenient way to show proofs to clients. Vericolor II, Type S, Daylight film is also fast enough (ASA 100) to catch exuberant scenes like this one of the bride with a flower in her mouth. 1/125 sec. at f/4.

Left: As the two little flower girls danced near the opening in the tent, I was able to shoot with available light. Normal lens, 1/125 sec. at f/5.6, Vericolor II, Type S. Below: This was a touching, wonderful second wedding for both bride and groom, whose children gave them away at the church ceremony. 100mm Rokkor lens, 1/125 sec. at f/4, Ektachrome-X.

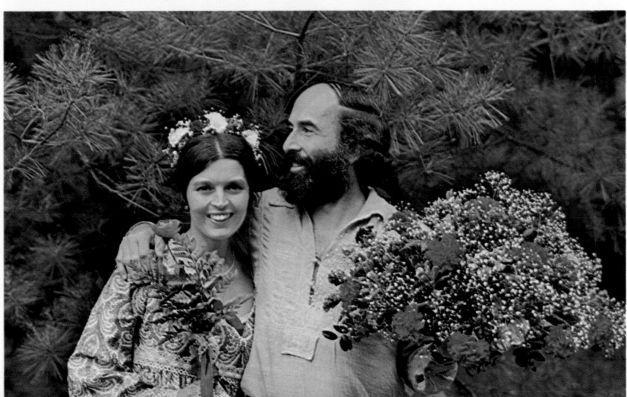

*Above: Of all the bridesmaids I have
photographed, I prefer the shots of
these attendants, dressed in
beautiful pink dresses designed
by the bride. They were all close
friends, gathered for the first
marriage among them. 1/125
sec. at f/4. Right: This lovely
flower girl was
photographed standing
close to a brightly lit
wall, which served as
fill-in; the sun
backlighted hair and
flowers. 1/125 sec. at
f/5.6, Kodachrome 64.*

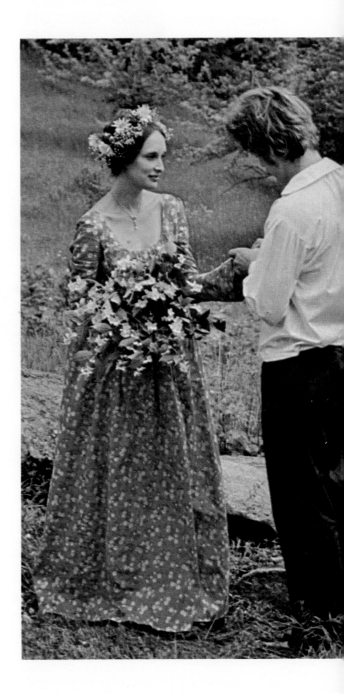

Above: An informal bridal portrait taken in the shade with a warm-up skylight filter. Both bride and groom wore garlands of flowers. 1/125 sec. at f/4. Right: If you'd like to compare this photograph with a black-and-white photograph of the same scene, turn to page 118. The black-and-white picture was taken with a normal lens, the color one with a 100mm telephoto lens. When working this fast with two cameras, built-in light meters are invaluable. 1/125 sec. at f/5.6, Ektachrome-X.

It's true that we photographers have our hands full covering all phases of a wedding. But I like to save some energy for observing everything that happens, be it touching, or funny, or unusual. This dog, decorated for the wedding of his mistress, behaved with dignity, walking among the guests as if to show himself off. 1/125 sec. at f/5.6, Vericolor II, Type S.

Ready at All Times

INTRODUCTION

In the next 73 pages, we shall go through a composite scenario of a wedding. We shall start on our way to the bride's house and take our first pictures there; follow the bride to the ceremony; then ride back with her to the reception and dance. Somewhere along the line, we shall set up for group photographs, then go on to dinner and dancing. All this time, we will take pictures of family and guests and observe the emotions that a wedding evokes in everyone. After the bride and groom have cut the cake and she has thrown the wedding bouquet, it will be time for their departure on their honeymoon. Our job will be over some five hours after it started.

We shall pay special attention to what equipment is needed in each of the above situations; and how we can simplify our photography and make it more successful at the same time.

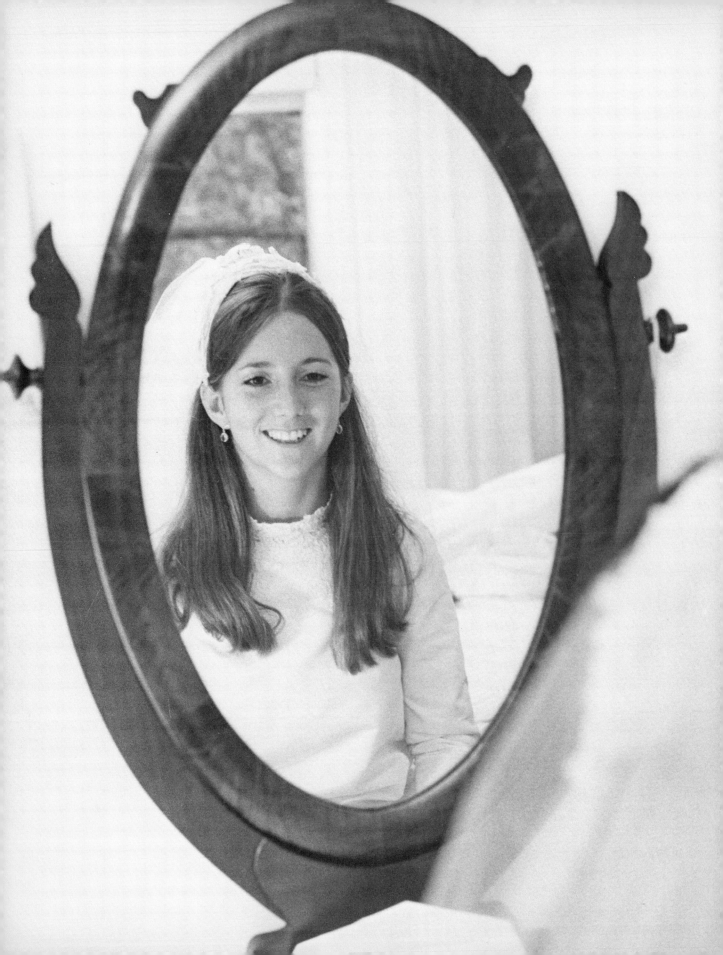

At The Bride's House CHAPTER 6

Strangely enough, the first piece of equipment that comes to my mind in order to be "ready at all times" is my car. Whenever possible, I drive to the wedding and use my nice, clean car trunk for storing everything I may need; that way I don't have to pare down my equipment to what I can carry. I can then take duplicates of cameras, plenty of film, extra flash parts, and batteries, and go get them if I need them. The equipment I know I will definitely need is packed into my four bags, ready to go with me.

SETTING UP

Since I arrive early, I find a parking space nearby. In summer, I try to make sure that the car is parked in the shade so that the sun doesn't overheat the trunk and ruin film and batteries. Another situation I am careful about is a really cold winter day, because lenses and film brought inside from the cold could freeze up and become misty.

As I showed on page 28, I always divide my equipment into four bags. Because I know which one I will need at a particular time, I stow the rest until needed. Where? Well, that's not quite as easy as you might think. It should be a place that is central; and that allows laying out some equipment (for instance, setting up the photofloods on stands, ready to move, or lining up unwrapped extra film on a shelf). A big walk-in closet is ideal if it is not in an area where all the guests pass by. Sometimes a corner in a little-used room will do.

I let the mother of the bride tell me where to make this little headquarters for myself. Sometimes, however, even she can make a mistake. I shall never forget one who ushered me into a nice, small room with a big table, near the kitchen. I spread out my equipment luxuriously; later, when I came back to get something, I found that the table was also being used for preparing a buffet and whipping cream for the homemade wedding cake.

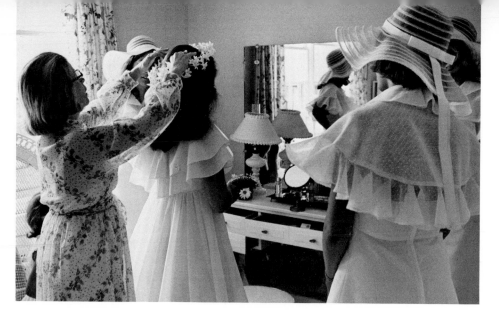

Available light boosted by one photoflood bounced from the ceiling. Normal lens on my Minolta SR-T 102, 1/60 sec. at f/5.6.

After this, I familiarize myself with the layout of the house. It isn't enough to know that the bride will come down a staircase; you have to make sure that there is only one. I also inspect all electrical outlets; some only function when a switch is flicked on. I make all adjustments before the guests crowd into the rooms.

By this time, I already know when the bride wishes me to start taking pictures. I set up one photoflood on a light stand in the room where she will get dressed, and another one in the room where the reception will be held if the wedding party is coming back to the house. I am always conscious of the necessity of preserving the decoration and festive appearance of these rooms. I try to hide my photofloods, using shelves and ledges to clamp some lights onto. I make sure that hot photofloods are far away from curtains and walls so that they don't cause any damage by scorching. I bounce them from the ceiling or walls, as I wouldn't want the guests to walk into harsh lights. If the ceiling is dark (a rare occurence, luckily), I have to forget photofloods and resort to direct flash.

TAKING PICTURES

After having made all these preparations, I can now go and photograph as much of the dressing as the bride wishes—of herself; her bridesmaids, who usually dress at the bride's house at this time; or the family that may gather to accompany the bride to the church.

Now the bride is ready. I photograph her alone, and with her parents, taking advantage of the lighting system I installed earlier.

The actual departure from the bride's house is so exciting, so full of good picture opportunities that I must have the bag containing my flash equipment ready at the doorway or, preferably, already in the car that will take us to church. That way I will be ready to leave with them, shooting all the time.

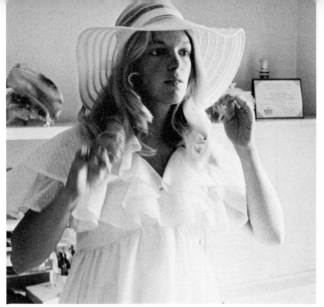

Some brides allow me to start photographing while they are still getting dressed. Available light boosted by one photoflood bounced from the ceiling. 1/60 sec. at f/4, Tri-X rated at ASA 800.

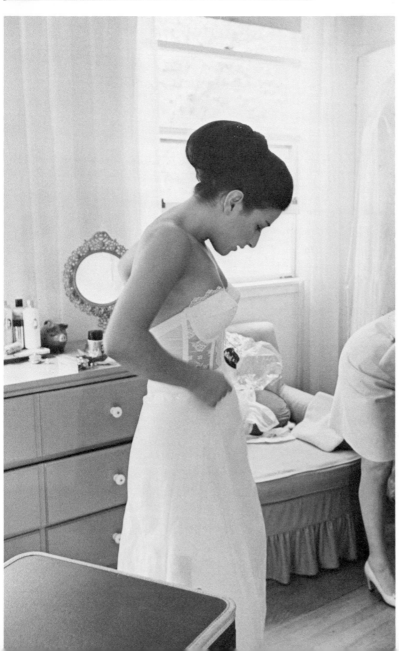

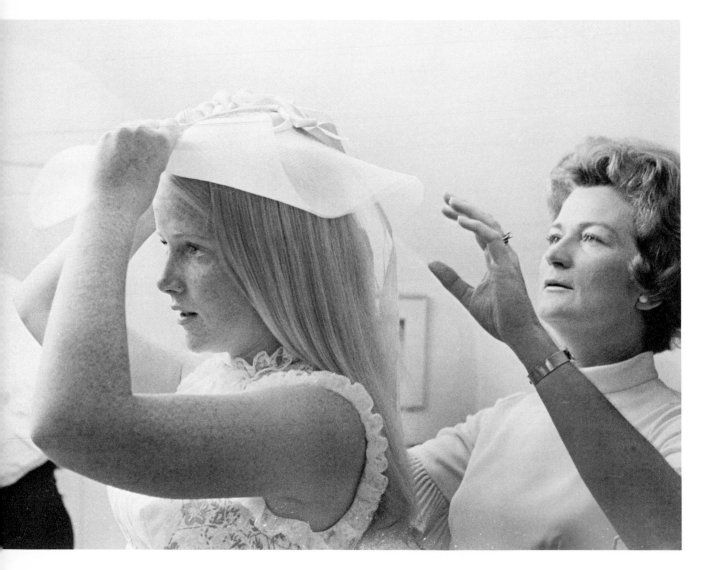

Left: Two bounced photofloods provided the only light in this picture. 1/60 sec. at f/5.6, Tri-X. Right: Again available light boosted by one photoflood bounced from the ceiling. Normal 55mm lens on my Minolta SR-T 102, 1/60 sec. at f/8.

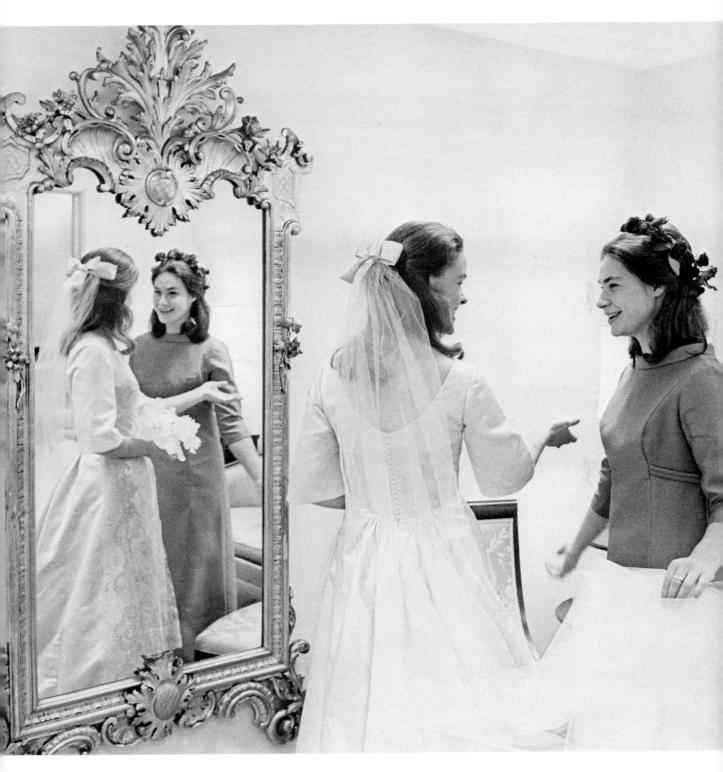

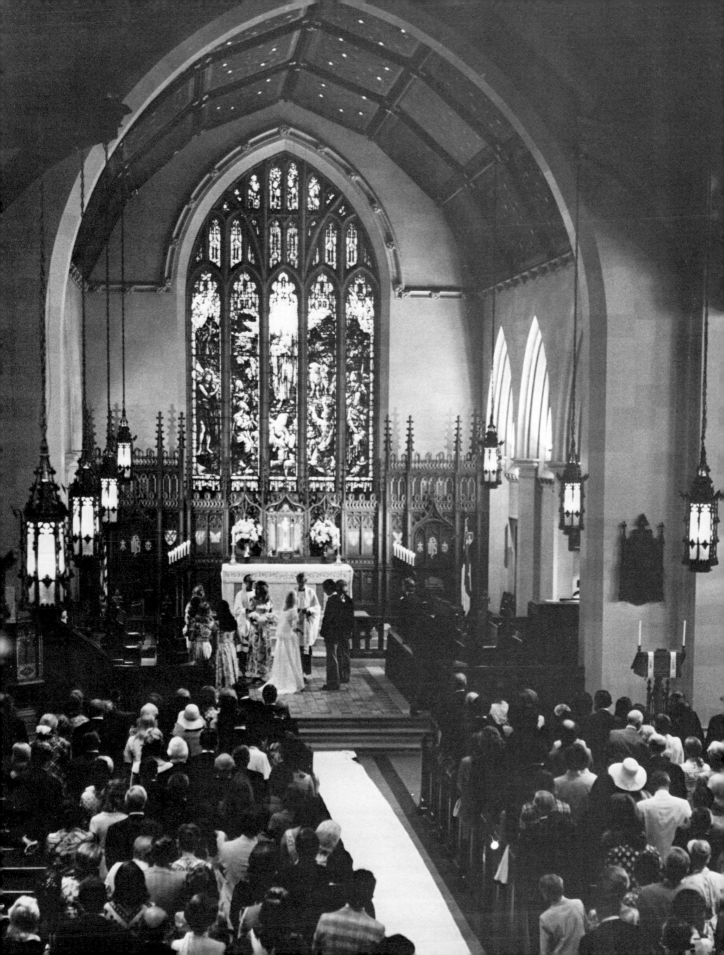

The Ceremony

I have never met a client who objected to my riding to church with the bride and her father. I sit in the front seat, near the driver, whether it is a limousine or private car.

Since the car is moving all the time and the light is changing constantly, a camera with a built-in meter is nearly indispensable. Except for the longest limousines, where a normal lens will work, a 35mm wide-angle lens will cover both persons in the back seat. My only problem comes when the bride's dress is so voluminous that her father cannot sit close to her.

Most fathers hold their daughter's hand, and many of them are touched to find themselves facing the ceremony that signifies "giving up their little girl." This is a situation which needs no admonition from the photographer. I am happy if they forget that I am there and taking pictures, and if they perhaps smile into the camera once or twice. Then I usually stop shooting and face away from them. After a minute or so, I turn around again and take another dozen pictures; these are usually the best ones.

I try to be out of the car and up the steps of the church by the time the bride emerges from the car. I quickly put down my second camera bag and the flash bag so I can move around, finding the best place to catch people coming into the church, the wedding party forming, and the like, without getting in the way.

After the bride has entered the church, I take up a position that has been agreed on beforehand—either in the front row of the balcony or a seat I have reserved for myself by putting one of my bags on it; or by going to a spot near the altar that has been pointed out to me earlier. I like to do this moving around while everyone is standing; I feel too conspicuous when I am the only one not seated. Meanwhile, I watch the time. I find out in advance how long the ceremony will last, so a few minutes before the end, I move to the back of the church to make sure that I do not miss one of the most important pictures of the wedding: bride and groom leaving the church.

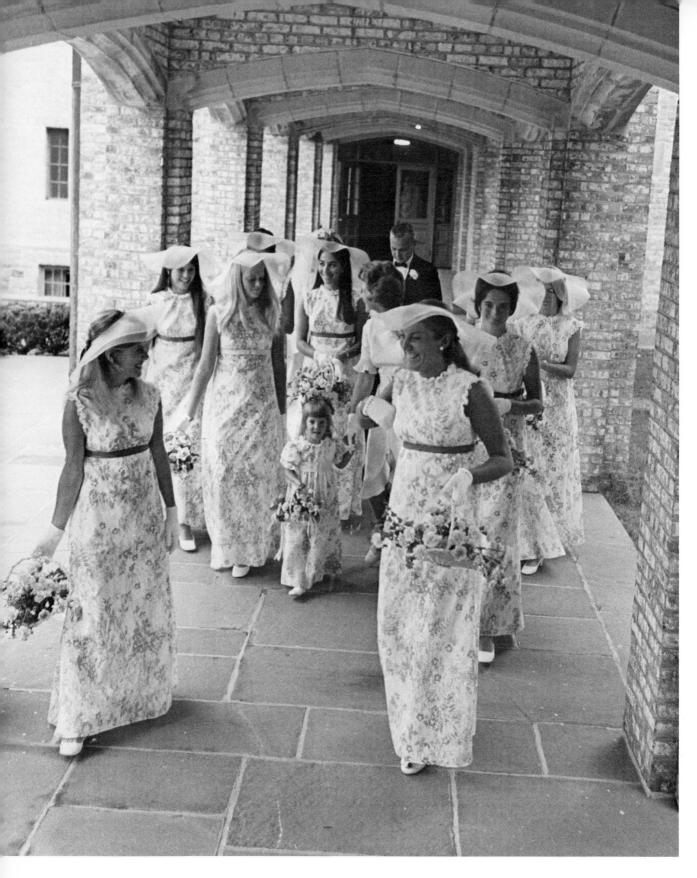

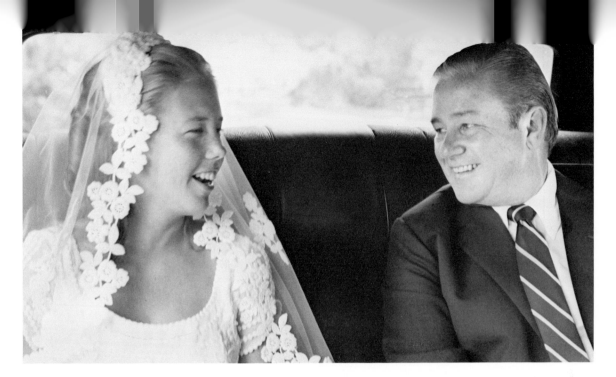

Left: Bridesmaids arriving for the wedding through the archway of the church. 1/125 sec. at f/8, Plus-X. Above: Traveling in the front seat of the bride's car, it is essential to have a built-in light meter to adjust exposure inasmuch as the light changes constantly en route. Below: These ushers—twin brothers of the bride—were waiting for the guests in the vestibule of the church. Available light, 1/60 sec. at f/5.6, Tri-X.

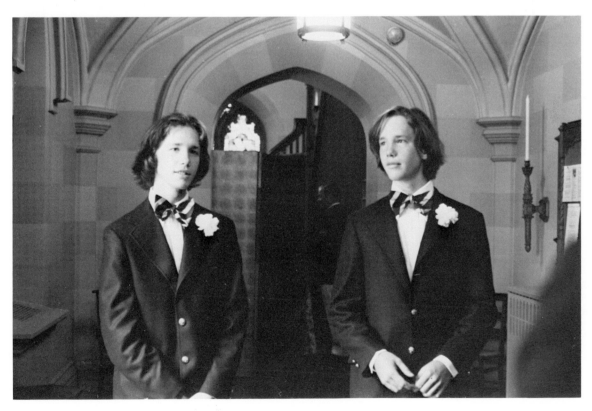

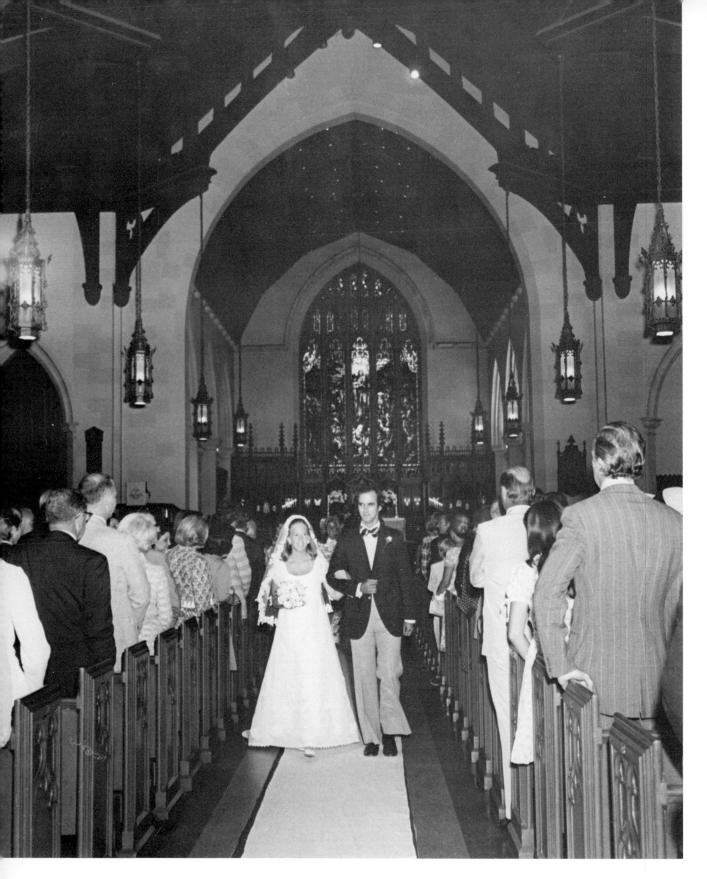

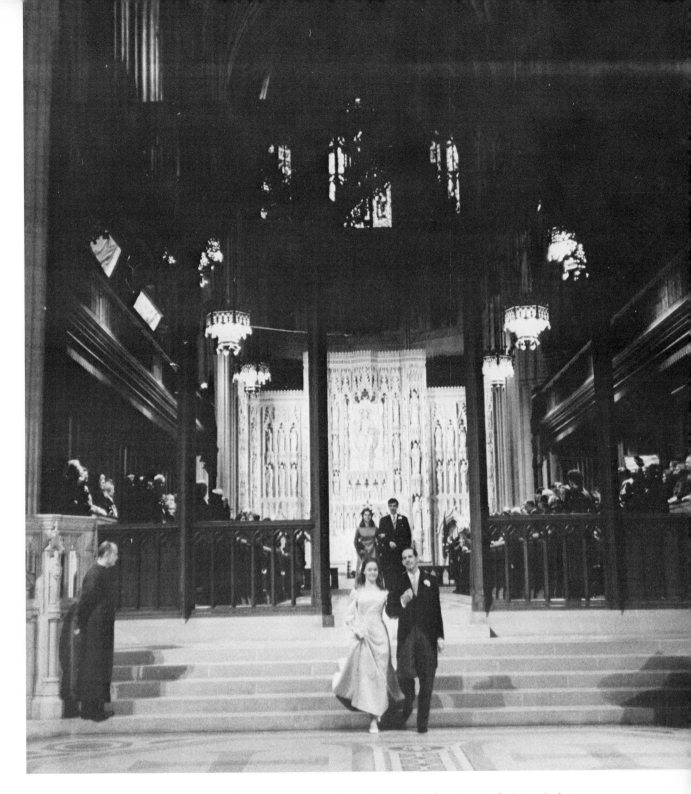

Left: Direct flash, f/11, Tri-X rated at ASA 800. Foreground required drastic burning-in during printing.
Above: Washington Cathedral doesn't allow photographers into the nave proper, nor are flashbulbs allowed. I picked a place where I could catch the couple leaving after the ceremony. It had sufficient daylight for an exposure of 1/125 sec. at f/5.6 using a normal lens.

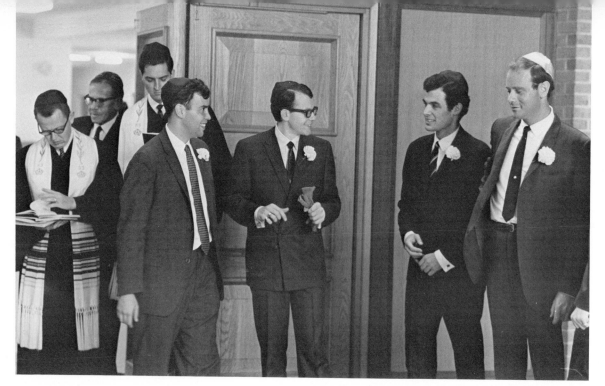

A Jewish ceremony photographed by available light. 85mm lens on my Minolta, 1/60 sec. at f/4, Tri-X rated at ASA 800.

Nearly always, this has to be a direct-flash shot. I like to prefocus on someone in a pew near the middle of the church, and I shoot when the couple reaches that point. Then I take a few steps backwards and catch them a second time.

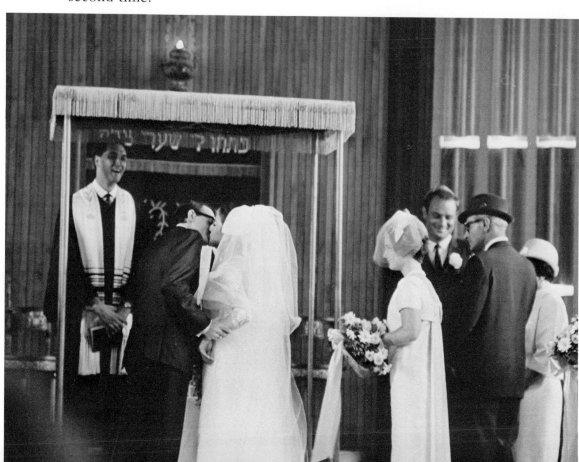

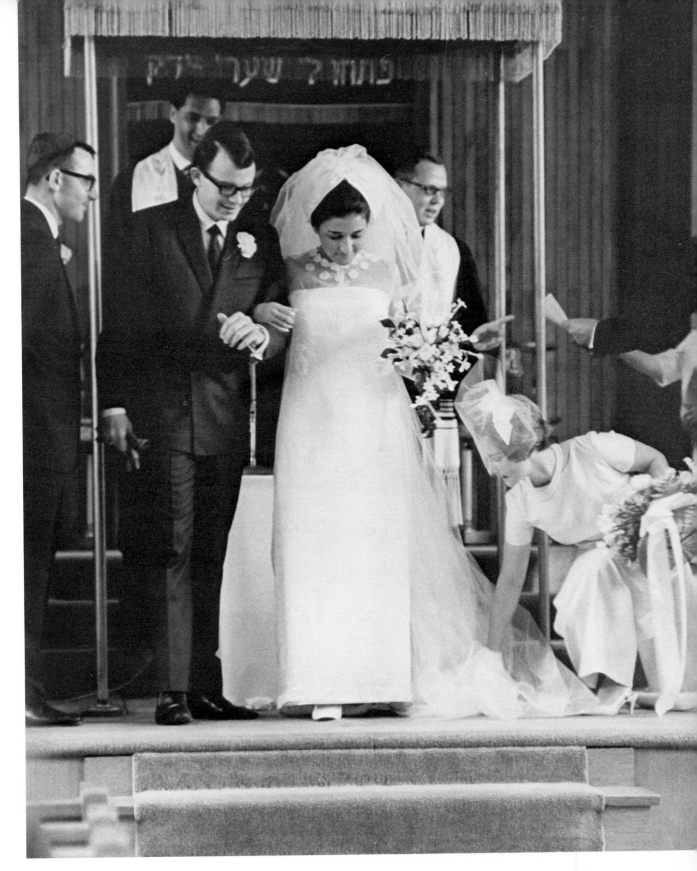

A good time to take pictures—but without ruining the special moment for the couples.

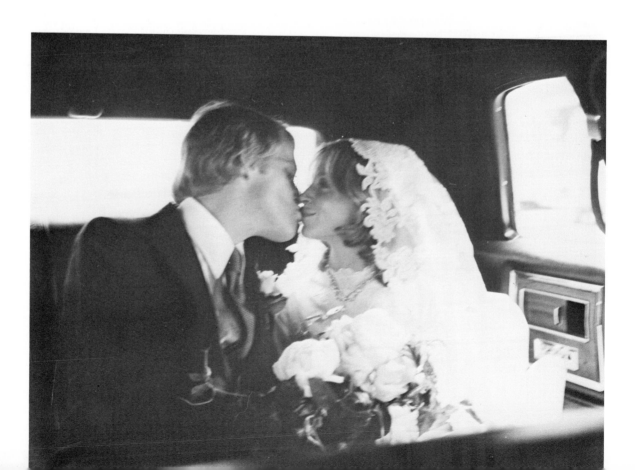

I quickly follow the couple into their limousine; bride and groom are certainly not in the mood to wait for me or even acknowledge my presence. I feel this is an awkward moment, since the groom has never before set eyes on me. If he looks at me in a friendly way, I say: "Congratulations! I hope your wife told you that I would be riding home with you." If he prefers to ignore me, I keep quiet and sneak my pictures of the couple beaming at each other or kissing.

When we get home, I ask the couple whether we could quickly take some pictures before everyone arrives and surrounds them. These few minutes can yield wonderful pictures.

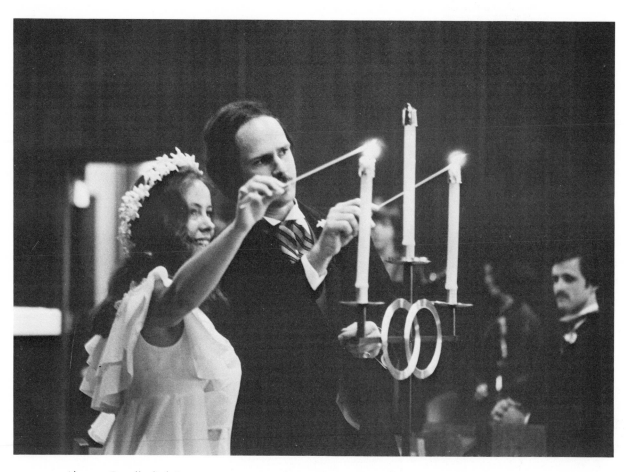

Above: Candle-lighting ceremony was shot with a 100mm lens on my Minolta camera. 1/30 sec. at f/2.8, Tri-X rated at ASA 800. Right: This bride and groom were caught as they waited for their car following the ceremony. 1/125 sec. at f/8, Tri-X.

90

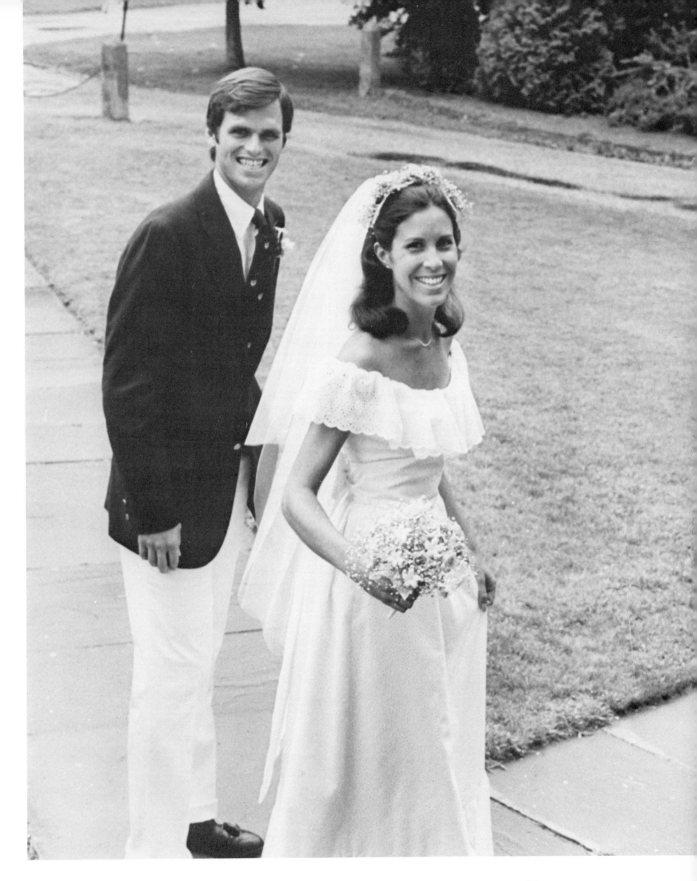

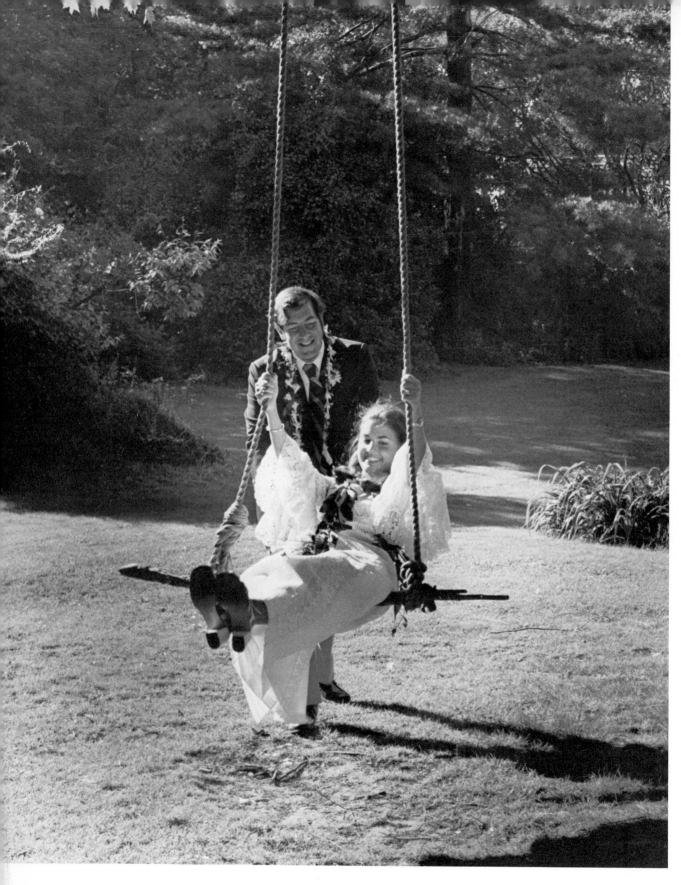

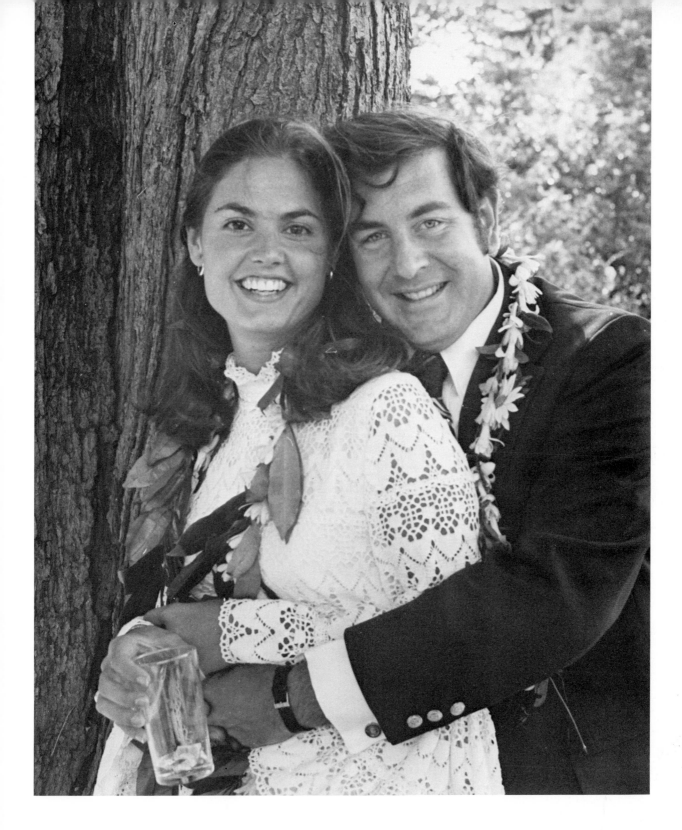

Informal photographs of bride and groom, taken just after the wedding ceremony. I made sure I caught them in soft, even light both outdoors and indoors.

93

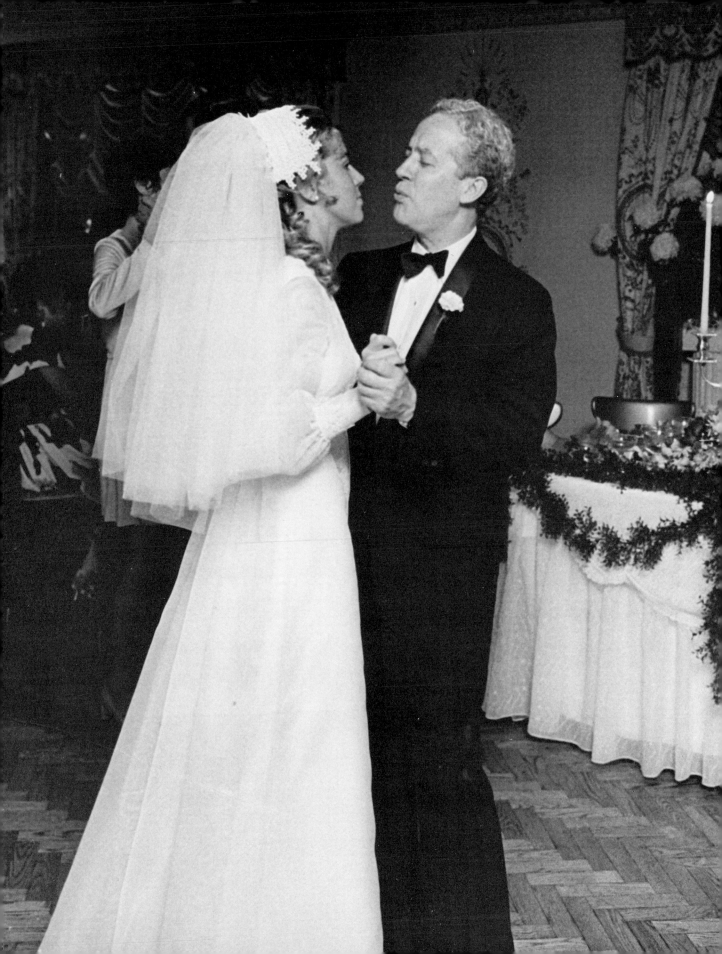

Reception and Dance CHAPTER 8

As the guests for the reception and dance arrive from the ceremony, it isn't feasible to have a period of rest although everyone could use it! As it is, this is the most hectic and difficult time for everyone concerned, including the photographer. There are nearly always last-minute slipups and changes in plan, especially if the reception and dance are held at a club or hired hall, not at the bride's house with which you have become familiar.

If you are a photographer who works out of a small town or suburb, you may have come to know these public places; if you work out of a large city, you'll be like me: From my studio in New York City, I have yet to go to the same club or hall a second time. All the weddings I have covered have been held in new, different places.

If at all possible, I start out early on the wedding job and take a peek at the place where the reception is going to be held before I go to the bride's house; then I can at least be prepared for what I will find there.

What next? Reload all cameras and put away the equipment I no longer need? Set up new lights for new situations? Concentrate on the receiving line? Shoot more closeups of the wedding party? Find a suitable location for the upcoming group photographs?

I would also like ten minutes to freshen up and have a glass of ginger ale. (No! not champagne. I get dizzy easily from it, and I don't think any photographer's pictures are improved by it.) But these ten minutes are hard to come by, so I usually try to do everything at the same time, fast.

I continue to keep the receiving line in sight, to catch important guests or witness reunions between people who haven't seen each other in years.

If the reception is held outdoors, I try to influence its location so that no one has to squint into the sun. But if there is no shady spot (as in the picture on page 96), it is more important to make sure that the faces of the bride and groom are in shade. By exposing for the faces, and because the sun was weak, I did not need a fill-in light. Using a 100mm lens allowed me to keep out of the way of the guests and gave me semi-closeups.

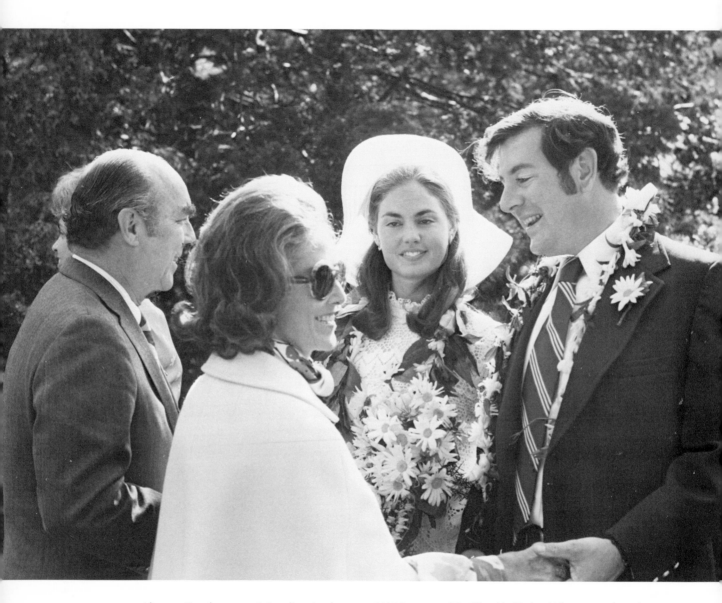

Above: Outdoor receiving line in the sun. 1/125 sec. at f/8, Plus-X. Right: Whenever there's space behind the participants in the receiving line, I go there too, to catch the faces of well-wishers. In this case, available light was strong enough to use 1/60 sec. at f/4. 55mm lens on my Minolta SR-T 102, Tri-X rated at ASA 800.

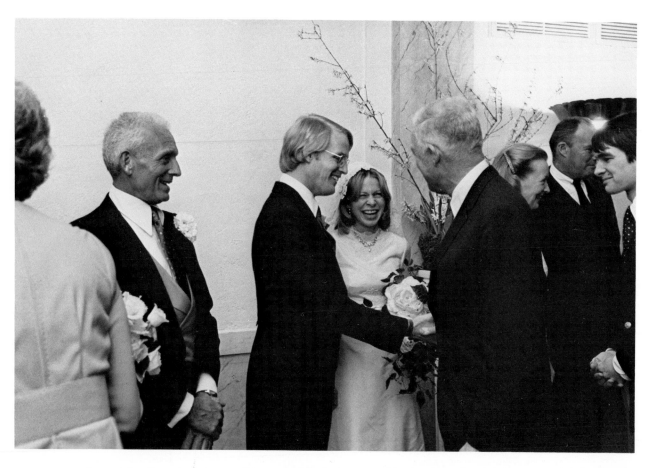

A receiving line close to a wall is not an ideal photographic situation. In such instances, it is important to use bounce light, otherwise the shadows on the wall will be very disturbing.

I also prepare for the group shots with the aid of the person who has promised to help me round up the participants. While they are gathering, I double-check cameras and lighting equipment, and see whether my meters agree on the exposure—all this while acting as nonchalant and patient as possible. More on group shots in Chapter 9, so let's go directly to what happens next: dancing.

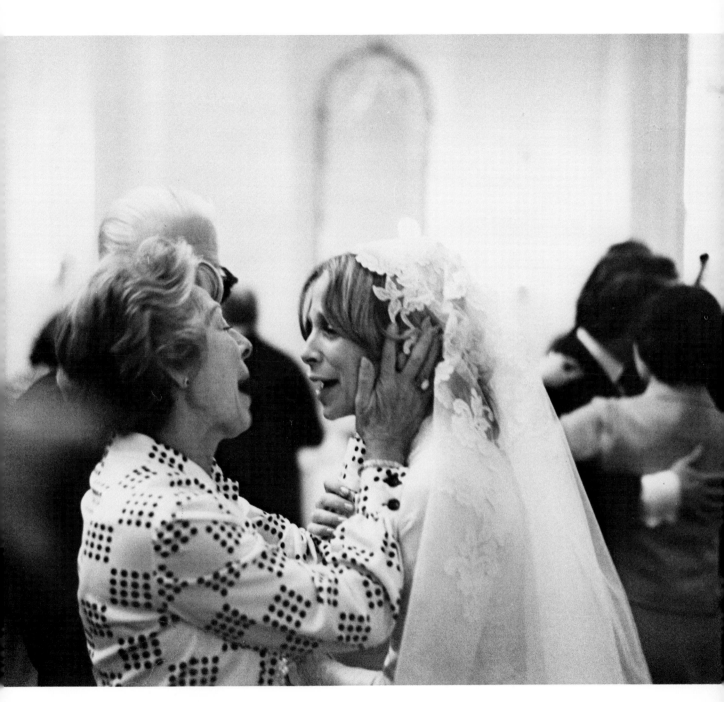

There's nothing like available light for catching an unexpected moment. People are so used to flash photography, that they cannot believe you are taking their picture without it. They often assume your flash is not working. I forced Tri-X to ASA 1600 by developing two to three minutes longer than recommended (by inspection, of course).

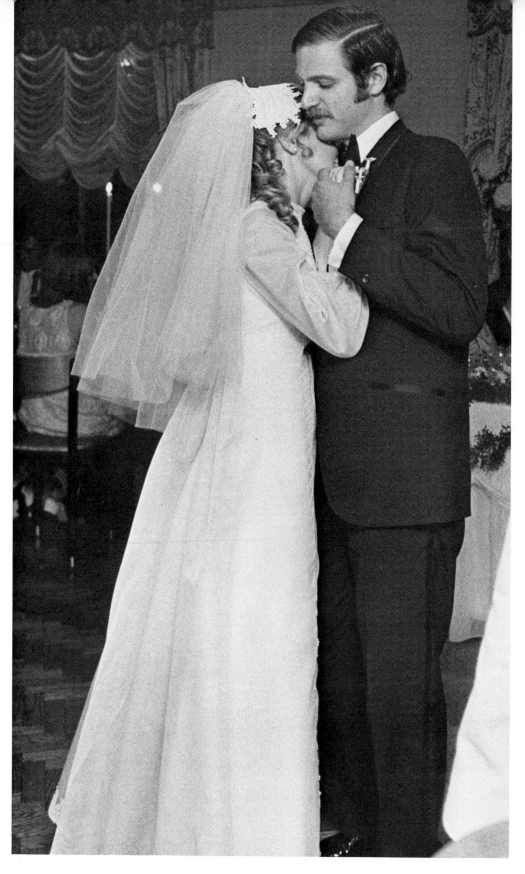

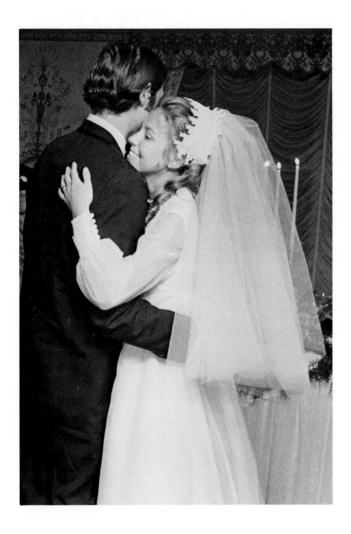

Dancing

Hurray for rooms that are large enough to accommodate some one hundred wedding guests but have ceilings low enough for bounce-light photography. These three shots were taken a few years ago when I did not yet have an automatic speedlight. I remember using a Mighty Light 100 watt-second unit at $f/5.6$, bounced. This meant opening my lens two stops wider than for direct-flash light. You may object to the bride's face being hidden in the first shot, but I like the fact that she preferred snuggling up to her new husband in their first dance rather than posing for pictures. Such a photograph will bring back happier memories than any posed picture; and, after all, you can always take another shot showing the bride's face. Sometimes you should give the groom a break!

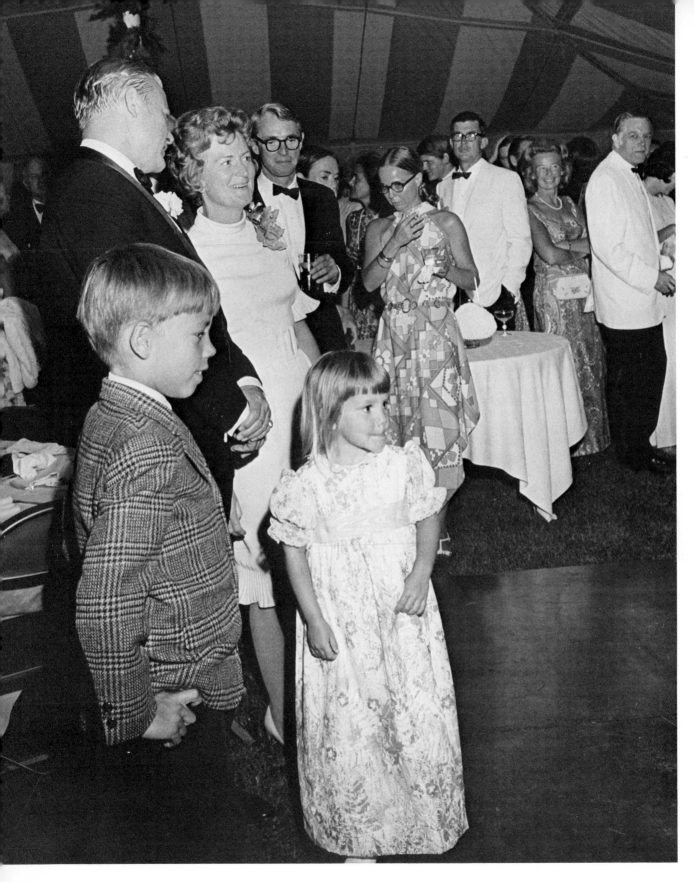

102

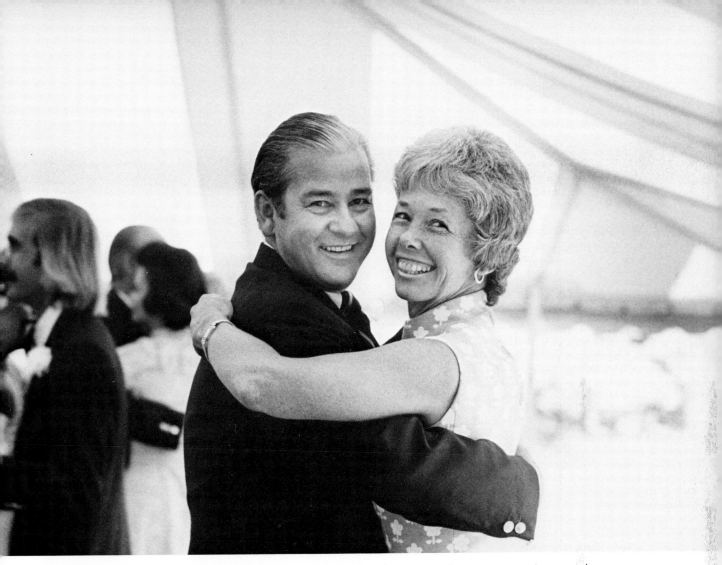

Left: These children were too engrossed in watching people dance to notice my preparations to take their picture with flash. Above: This shot was taken either by available light alone, 1/125 sec. at f/2.8, or helped by bounced speedlight, 1/60 sec. at f/4, Tri-X.

Weddings held in tents are among the most luxurious and lavish, but they present special problems for the photographer. The tent is usually set up on the lawn, so you cannot expect to have electric light. This not only rules out my secret weapon, the photoflood, but makes focusing really difficult. People may like to dance and eat by candlelight, but the moment you use direct flash, this charming atmosphere is completely changed and your photographs will look nothing like the real thing.

On a sunny day, in a light-striped tent, the job is much easier than late in the day. There will be plenty of available light to focus by, and you can catch dancers by bouncing flash or speedlight from the tent ceiling, which is fairly low at the sides. Here the danger of double images is great unless you are using a camera that synchronizes at all shutter speeds, not only up to 1/60 sec. (as with focal-plane shutters).

Two very different dancing pictures. In the first, a couple stops to pose for my camera; as I will explain later, I think weddings offer a great opportunity to take candid portraits of people in a happy, relaxed atmosphere. What other occasion could bring a couple this close together? I am sure they would have felt silly posing for me at home this way. I preferred a long exposure by available light to using flash or speedlight. 1/30 sec. at f/2.8.

The couple on the opposite page, having seemingly been caught dancing alone, may look posed, but was not. I stationed myself in the midst of the dancers and took many shots against the trees. 1/250 sec. at f/5.6.

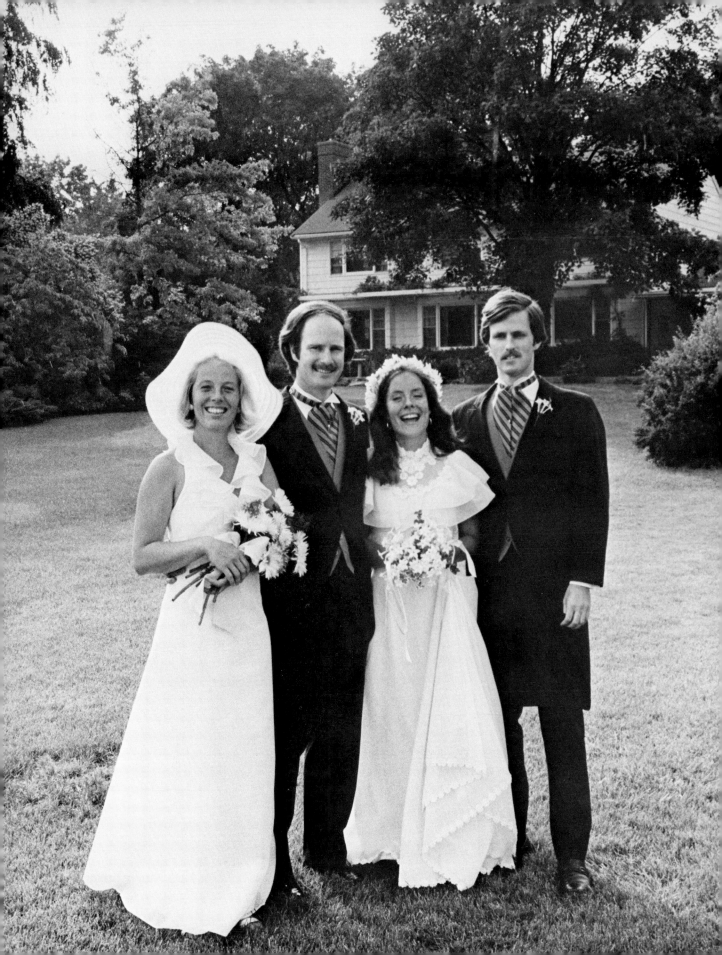

Group Photographs CHAPTER 9

I feel strongly that a wedding is not only a religious and social event, but an ancient custom that revitalizes and strengthens family bonds. The group picture is a testimony to the importance and stability of the family.

These days, the family is still important, but often less stable. If divorced parents have remained friendly, they may both attend the wedding of their child. I once urged the bride's father to join the group I was about to photograph and was told that his place was going to be taken by the bride's mother's current husband. I haven't "helped" since in forming family groups; it is strictly their decision as to who belongs in what group photograph.

As I mentioned in one of my checklists, see page 29, it is very important that you and the family agree in advance *when* the group shots will be taken. The choice usually boils down to one of two times:

First, just *after* returning from the ceremony, but *before* the receiving line is formed. This is only possible if the arriving guests do not have to be ushered into the same place where you are trying to take the pictures of the family and wedding party; otherwise, there will be no end of interruptions and distractions, and the participants will be impatient and feel badly about holding up the guests.

Second, *after* the guests have been through the receiving line, but *before* dancing starts. True, the bride and groom will be more tired at this point than before standing in the receiving line, but they will also be relieved to have gotten it over with; and after freshening up a bit, they will look their best for the photographs.

If I can, I tell one or two younger family members or close friends to help me find all the participants. It would be nice if someone could announce: "Group photos in half an hour," but this never happens, and no wonder! Photography is considered by most a necessary nuisance, and the photographer needs a lot of tact to get a large group together in a good mood. Even if people know that they will treasure that photograph a few weeks, months, or years later, they would much rather not bother with it then and there.

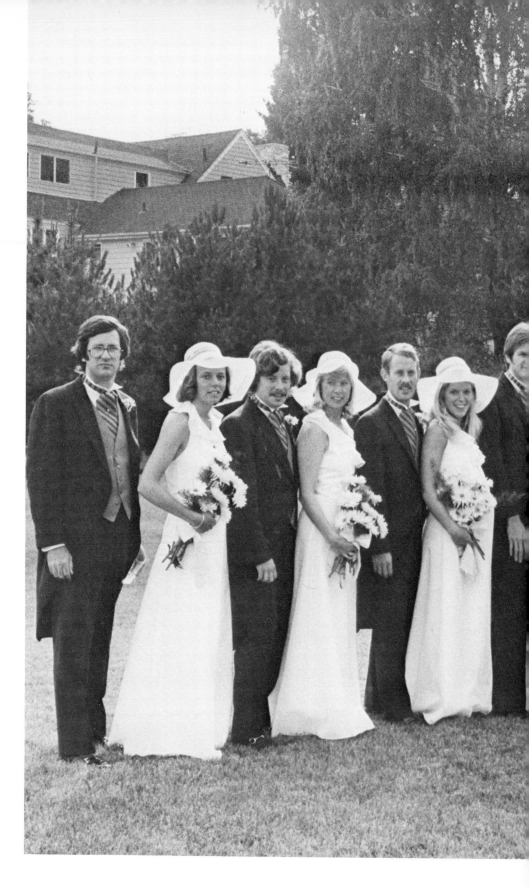

One of four group photographs from the same wedding, which appear in this chapter. Here, the whole wedding party was pictured. On the chapter opening page, the bride and groom are pictured together with the best man and maid of honor.

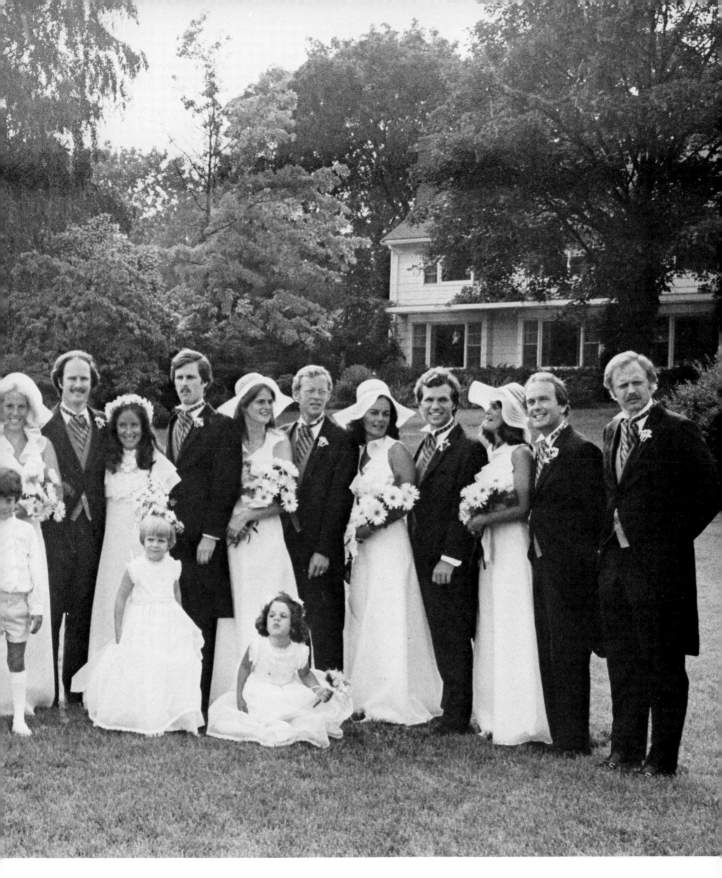

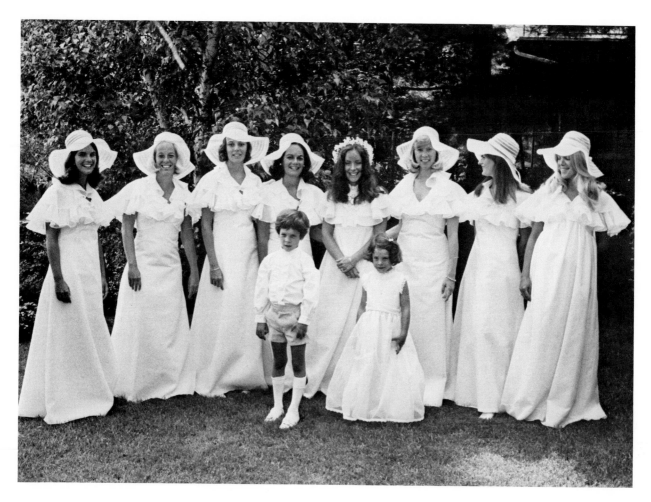

The bride, her bridesmaids, and train bearers.

Partly to keep myself from getting impatient, I start shooting the moment the group begins to form. I have taken some charming pictures of one person fixing another's hair or attire, or of a reluctant child being coaxed into cooperating.

GROUP PICTURES OUTDOORS

If you are lucky and can pose the wedding party outdoors, there are fewer problems than indoors. But there are problems nevertheless, and many questions arise. Examples: Is there a location in open shade, in front of a pleasant,

110

undistracting background? Can you compose a picture so that people will show at their best? And so on.

I cannot overemphasize how much easier it is to shoot in open shade, where everyone can look into the camera without squinting, and there are no extremes of light and shade.

If you cannot find such a location, and the sun is shining, there is only one thing to do: pose the people with the sun *behind* them, and use flash for fill-in. And while you figure out the ideal *f*/stop that will make the picture look natural and not overly filled-in, you probably will have to put up with the sun shining in *your* eyes. Well, this is still preferable to having it shine in your subjects' eyes!

Finally, the couple with both sets of parents and one set of grandparents—a three-generation photograph!

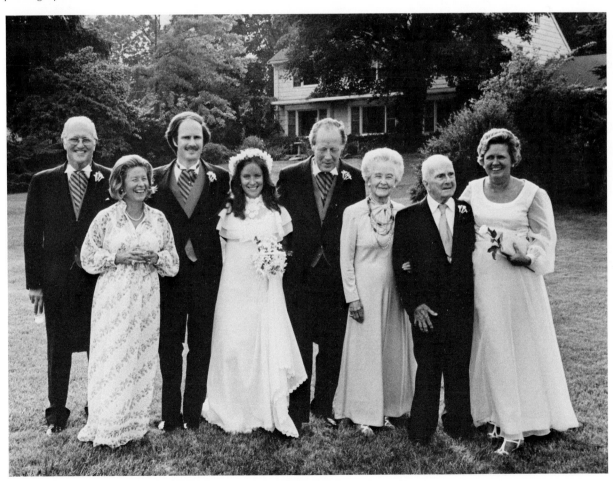

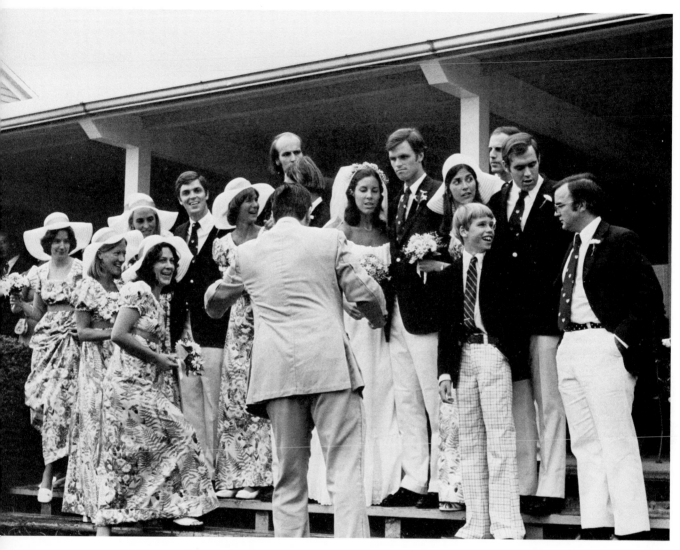

A fellow professional in the process of arranging a group shot. Excessive manipulation doesn't seem to ingratiate him with some of his subjects.

112

How to achieve a photograph in which a score of people look their best is hard to describe. I don't resort to the "Hold it!" technique unless all other methods fail (which is seldom).

Before that, I try to look at every person, one by one, to make sure that no one is hidden; then I tell them that if they can see the camera, the camera will see them. I remain cheerful no matter how harassed and unhappy I may be with the way things are going, and if this still doesn't produce a friendly, relaxed atmosphere, I ask someone to help me by entertaining the group with a silly story, joke, or song. This will do wonders! I can't tell you how I pick and persuade this helper, but it is interesting that there seems to be a natural candidate in every large group.

An unusual group at a wedding: the groom and his father; the bride's father and her brother; the groom's brothers and a female cousin; plus other guests. The reason they wanted to be photographed together? They all went to Princeton!

Above: A quick family group shot, taken before the bride, her parents, and her sister left for the ceremony. Available light boosted by one bounced photoflood, 1/60 sec. at f/5.6, Tri-X rated at ASA 800. *Right:* A small wedding party, photographed indoors with two direct photofloods mounted on stands. I pulled the sofa away from the wall partly to allow easier grouping of my subjects, and partly to minimize shadows that cannot be avoided when using direct lighting.

114

GROUP PICTURES INDOORS

If the group photos have to be taken indoors, you need more preparation. If the reception is at the bride's house, I use the photofloods that I left there earlier; if I find myself in a club or restaurant, I will have made sure that the lights are in my car or that someone has brought them along. If at all possible, I use bounce lights. But sometimes the group is so large and the ceiling so high and/or dark that this becomes unfeasible; in such cases, I turn two floodlights directly on the group, making sure that they light everyone evenly. Posing the group away from the background will lessen ugly shadows. However, these shots are not among my favorites.

If you are experienced in using extension flash or speedlight, or one with a slave, this is a good time for this method.

The Wedding Guests CHAPTER 10

Maybe you think it is a luxury to take any "unrequired" pictures when you already have your hands full getting the important wedding pictures. Shooting these additional photographs certainly takes more film and processing time, but I am convinced that it is not only my hobby, but my job to do so.

One bride was able to put it into perspective. She said: "I shall probably be so excited I will hardly know what's going on; besides, I'll be standing in the receiving line some of the time, so *you* must show me what went on at my wedding."

Even brides who don't think of it this way often comment on the surprises the pictures hold for them when they see the first batch of prints. "Did my little sister really cry during the ceremony?" or "Is that really my bashful cousin Ellen flirting with the usher?" or "Wow, my parents really looked bushed in that picture you took after we left!"

In order to document the whole wedding, my training as a photojournalist comes in handy. I am used to taking risks on long exposures, (down to 1/30 sec. or even 1/15 sec. handheld); on shooting by the light of candles or a table lamp; and on developing longer than the standard time. Naturally, I use Tri-X and set my light meter at ASA 800. Sometimes, if I can expose the whole roll evenly, I even shoot at ASA 1600.

Having worked in black-and-white for magazines like *Life* and *Look,* I never underestimate what good black-and-white photography can do and why it can even be superior to color in wedding photography. For more on my way of working in color, see Chapter 5 and color section.

When photographing the wedding guests, I walk around with two cameras. I use one for available-light situations; the other I use for the times when I need speedlight, so my camera is attached to it. As there is extra film in my belt pouch, I can forget about carrying a bag, which makes me less conspicuous.

Guests at an outdoor wedding in Vermont. It was a pleasure to photograph this wedding; the guests were informal and very much at ease, and the cloudy sky made it ideal for shooting in all directions.

Some people don't quite understand my way of working. "Why didn't you tell me you were taking a picture?" they say, "I would have turned around and smiled." Instead of explaining that I prefer unposed pictures, I just say that it is not too late, and then I take the expected smiling-for-the-camera photograph.

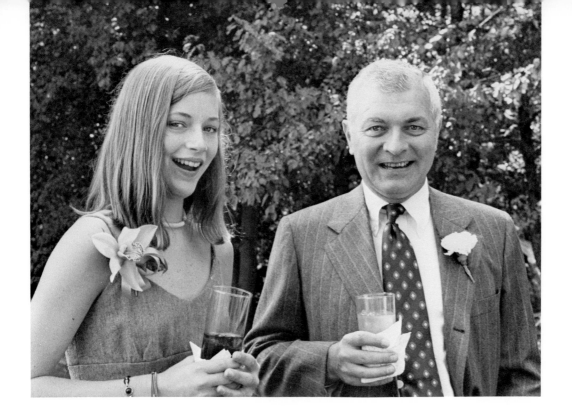

Above: Father-daughter look-alike at a wedding. Below: At this wedding, the bride did not ride home immediately after the ceremony, but stayed around to talk to everyone who had come. So I had time to photograph this family of five outside the church. Ironically, the family had made many attempts to bring all the members together for a photograph, and so they were very happy with this shot and used it for their Christmas card that year.

Opposite: I am very conscious of the grandparents at each wedding, for it is a red-letter day in their lives to see their grandchild get married. Too often they live far from the rest of the family and have made an effort to be there and participate in the festivities. In many cases, my pictures of them take on added significance and value later if they happen to be the last good pictures of them. Above: Reunion between groom and best man. Two photofloods bounced from the ceiling supplied the overall soft light that allowed me to shoot as if by available light.

Opposite: Near the end of the wedding lunch, I was wandering among the tables (set up under a tent) when I noticed a tableful of the bride's friends having a gay old time. Rather than rearrange and disturb them, I preferred to get candid shots of half the table at a time. Because the light was falling off toward the center of the tent, I bounced a speedlight from the canvas. This made the difference between the exposures needed for inside and outside the tent smaller. 35mm wide-angle lens, 1/60 sec. at f/4, Tri-X. Left: I had noticed that these three young musicians playing beautiful baroque music seemed to have a different relationship with the family than members of the usual "band," so I made sure I got a picture of them. Above: At her mother's second wedding, Suzanna brought out her violin and played along with the professional musician. Her mother was touched by this surprise and included my shot of it in her wedding album.

Cutting The Cake
and Throwing The Bouquet CHAPTER 11

Today's elaborate cake grew out of three modest wheat ears, which the bride carried in her hands as a symbol of fertility in ancient Roman times. Later, the wheat was baked into small cakes and thrown at the bride. Since then, the ritual has been split into two: the cake is now eaten, and, instead, rice is thrown at the bride and groom when they leave.

Weddings all over the world feature elaborate food and drink. Old European wedding feasts, even in simple peasant households, were often day-long, nonstop eating bouts. Some minorities brought special customs to America when they emigrated here. For example, Polish ceremonies often include a scene in which the mother offers salt, bread, and wine to the couple, and the bride and groom eat the bread and salt and sip the wine. This symbolizes that they start out with the sweet and sour.

CUTTING THE CAKE

There is little hope of photographing the cake-cutting by available light. It usually happens in the middle of a large hall, late in the festivities. If at all possible, I reinforce whatever light exists with a couple of photofloods. As I explained elsewhere, this not only allows me to shoot continuously and unobtrusively, but also lights up the scene for the wedding guests who are watching. I find this preferable to dim light alternating with flashbulb popping. The photofloods can be bounced or aimed on the scene directly from two sides.

But most of the time, flash or speedlight is the only answer to recording the cake-cutting. If possible, I bounce them so that the cake in the foreground isn't hopelessly overexposed.

I have yet to find a way that really satisfies me for taking this important picture. Between the need for showing the cake, and two people moving around, I often end up with shadows I don't like or a cake I have to burn-in when printing in black-and-white. Partly because the cake itself intrigues me,

Right: A photograph of a beautiful wedding cake. I always include such pictures in the album I present to the client as I feel they make it look better. Below and opposite: Using photofloods has many advantages when you want to shoot continuously and unobtrusively. 1/60 sec. at f/4.

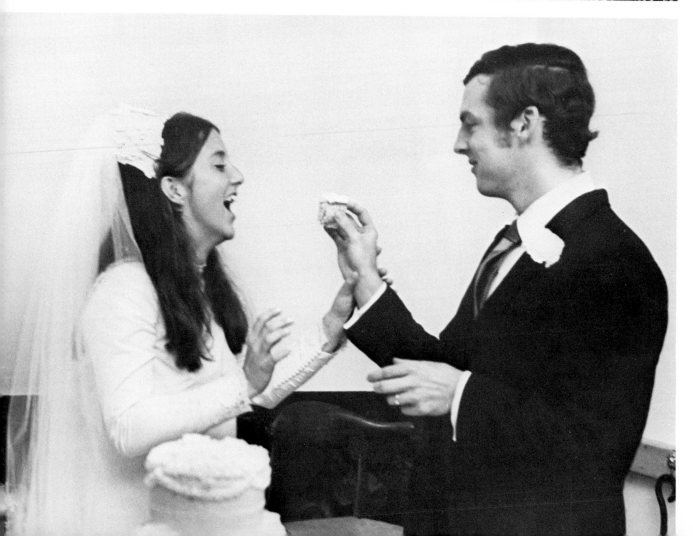

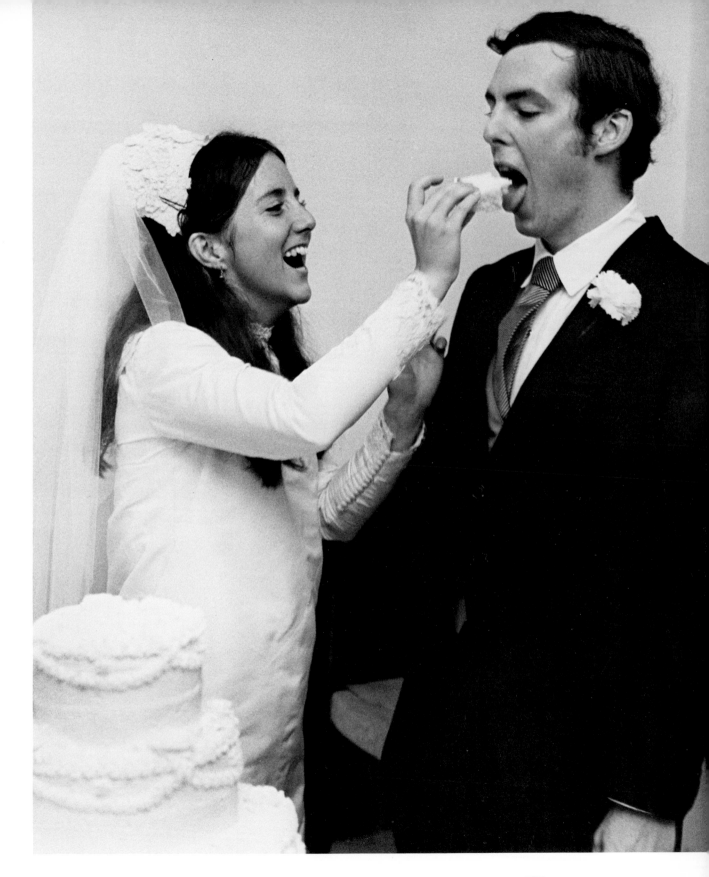

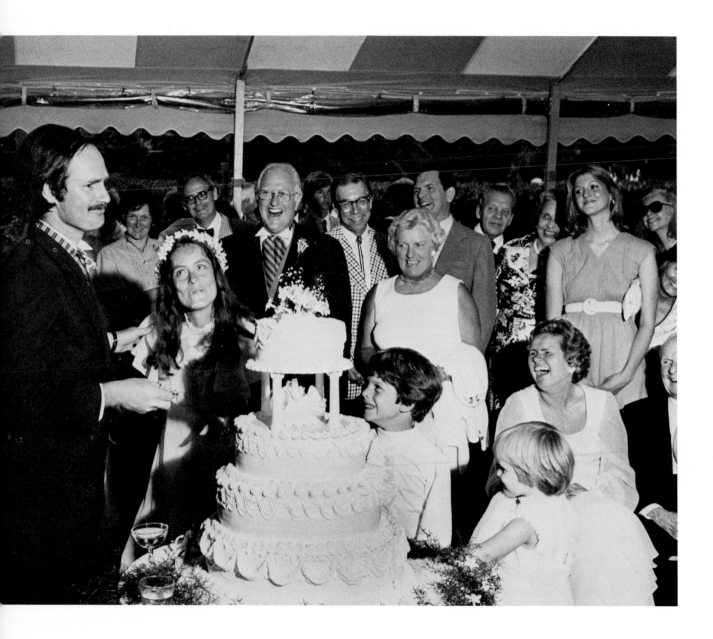

and partly to make sure I do get a good shot of it, I always photograph the cake by itself. Now I don't expect such a shot to be one of those the bride chooses for her important shots; I just throw these in to make the album look better, at no extra cost to the client. I also do this if I like a funny picture of the bride and groom (as the one on this page). There are always funny pictures when they cut and eat the cake, but the client orders only the dignified ones.

Automatic electronic flash (Minolta Auto Electroflash 450) with a recycling time of three seconds made it possible to catch the bride the moment before she threw her bouquet, and one of her bridesmaids right after she caught it. Plus-X rated at ASA 200.

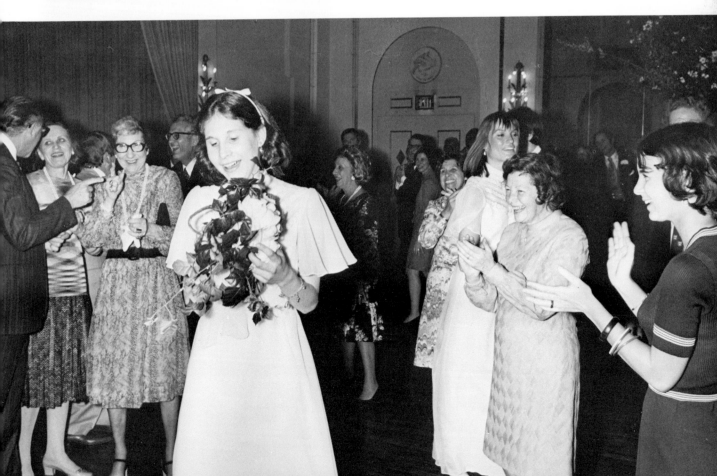

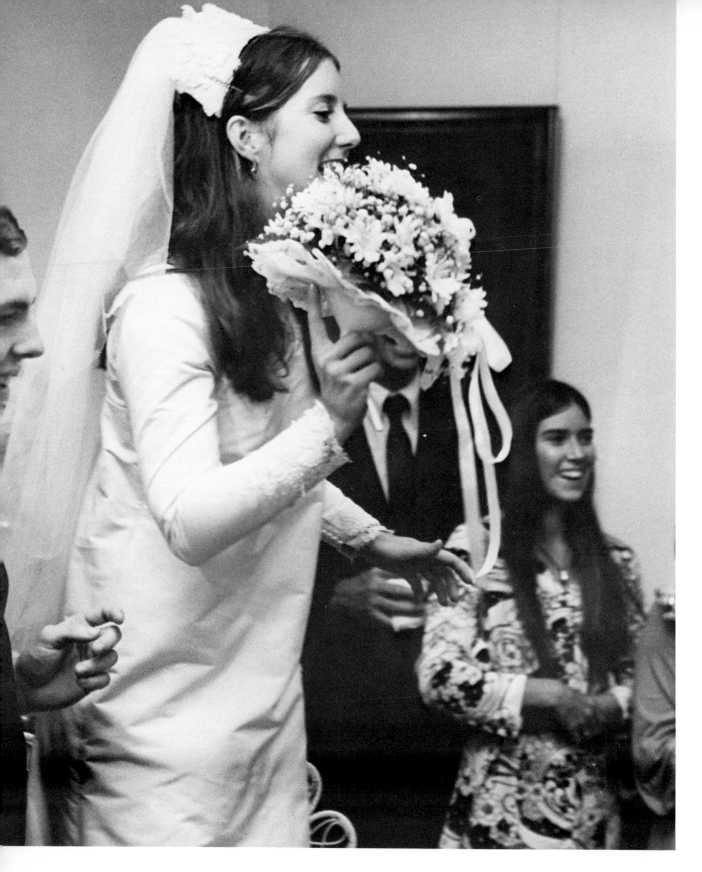

130

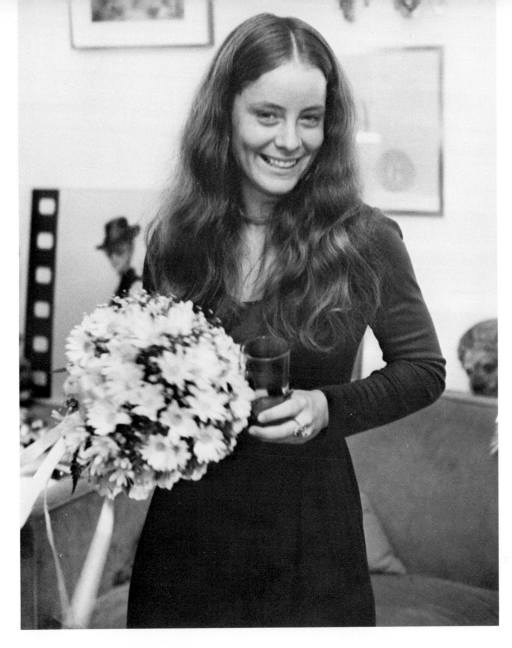

In this room, I was able to bounce my speedlight from the ceiling. Normal lens on my Minolta camera, Tri-X rated at ASA 800.

THROWING THE BOUQUET

The bride throws her bouquet and whoever catches it will be the next to get married, so the story goes. Unwritten law gives first crack at it to the maid of honor and the bridesmaids, and they stand in the front row to play out this old custom.

The trick in photographing this scene is to wait long enough to see the bouquet already in midair, showing the bride too, and then, in the next second, the lucky bridesmaid or guest catching it. As you nearly always have to rely on direct flash, and have to refocus between the two shots, it is next to impossible to achieve this. I have fallen back on showing the bride just before she throws her bouquet, and the bridesmaid just after she has caught it.

131

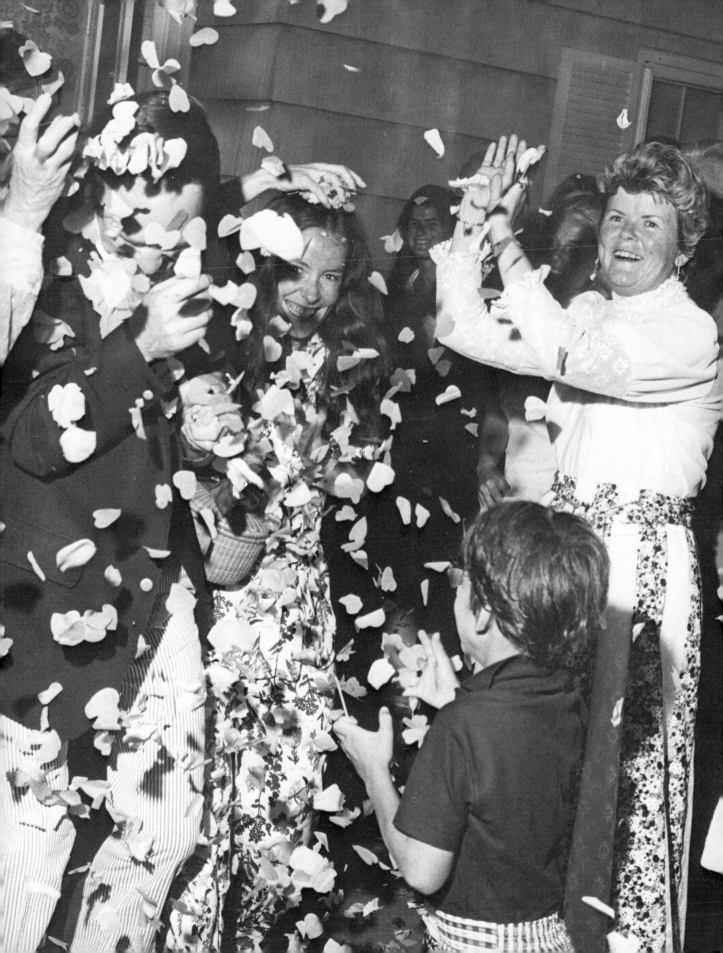

Going Away CHAPTER 12

As you must have gathered by now, I am not in favor of staging any photograph during a wedding coverage. People have better things to do than act and pose, and my job is to take good pictures of everything that happens. So it is inconceivable to me to pose a "going-away" shot before the couple actually leaves, just so that I don't have to wait until it really happens. If by any chance the couple wishes to have a four-hour dance before leaving on their honeymoon (this is rare, but it happened to me once), then they will probably be considerate enough to do without this kind of shot. On the other hand, I do record other incidents that take place around this time, at the end of the day.

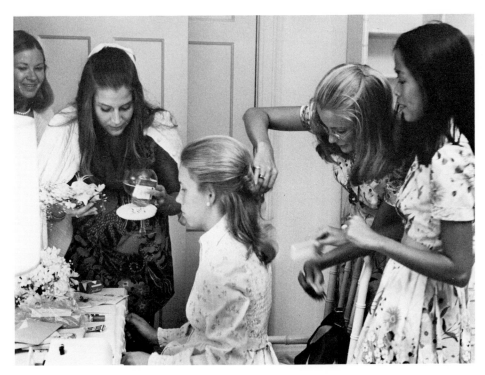

Back in the bride's room, her attendants help her dress for going away on her honeymoon. The bride has been smiling, talking, and on her feet for hours and hours, and now is a chance for her to just sit and relax. My photofloods were still in her room from earlier in the day, and I used them here, bounced from the ceiling. Minolta SR-T 102 with 55mm lens, 1/60 sec. at f/4, Tri-X rated at ASA 800.

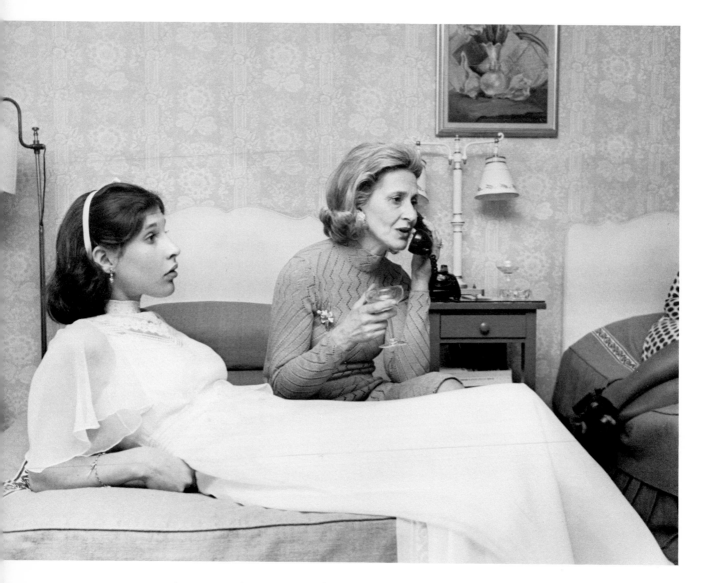

A moment of weariness and confusion while the bride's mother and bridesmaid wait for her to get dressed.

This shot of the couple leaving in their car looks positively dangerous; in reality, they were backing out of the driveway to avoid running over the enthusiastic well-wishers and pranksters who were showering their car with rice. I am always pleased when I get a shot of a crowd in which everyone is concentrating on the action and has forgotten about my presence. Available light late in the day, 1/125 sec. at f/5.6, Plus-X rated at ASA 200.

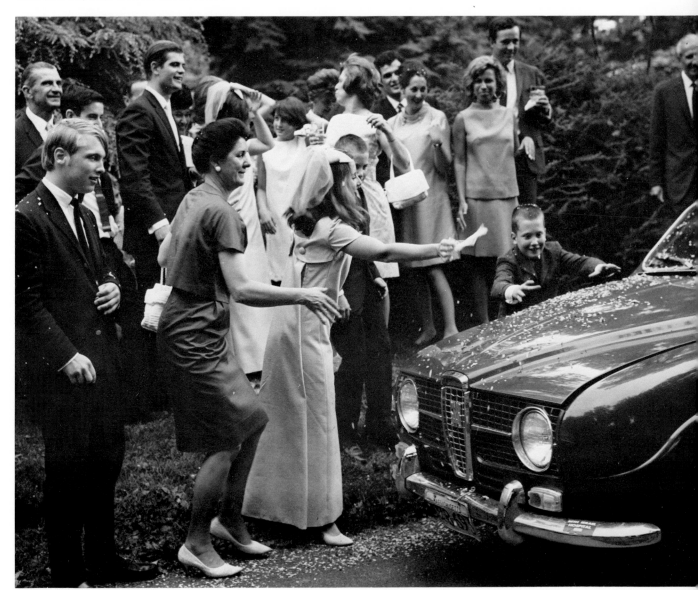

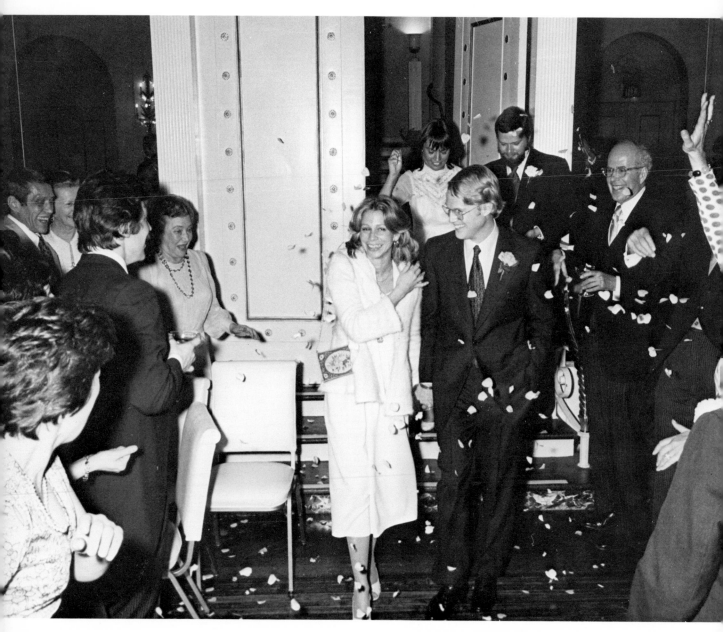

Above: Trapped in the crush with my camera. I expected the couple to leave by another door, where I waited, standing on a chair. Then I saw people congregating in front of another door, so I followed them, but it was too late to get a better position. What I got was one crooked picture, but it does show the good-humored frenzy characteristic of going-away scenes. Right: After the couple left, I walked back into the room where the reception and dance had been held and noticed the floor littered with artificial rose petals. It seemed like the perfect shot with which to end the day. I always take the shots that please me as a photographer and add them to the album as a gift. It's nice to give your clients more than they expect.

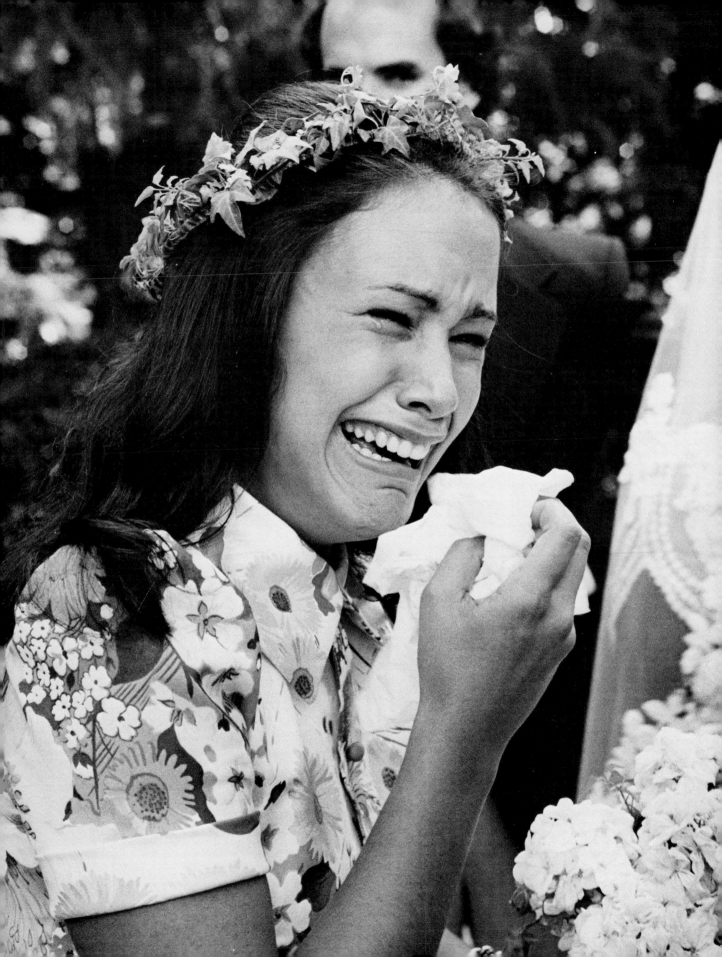

Wedding-Day Emotions

We take it for granted that bride and groom will be happy on their wedding day. This may be truer today than ever before, because women do have other alternatives besides marriage. Happiness is manifested in many ways: big smiles, certainly; hands seeking physical contact; constant leaning toward the loved one, not away from him or her; a relaxation of muscles after the tension of the weeks of wedding preparations. The photographs will subtly show all this.

The first time I felt I wanted to do my own book on wedding photography was when a fellow photographer criticized me upon seeing the picture of the bride and groom on the following page. "Why didn't you wait till their faces were showing?" he asked. I feel that this photograph radiates happiness. Naturally, this is not the picture that the couple will give to Grandma for framing, but it is their favorite.

The emotions of a bride toward her parents are much more complicated. She is supposed to be happy to leave, but it isn't all that easy, especially if she has lived at home all her life. And even if she has no regrets herself, she is just a little embarrassed to show her happiness in front of her parents; she sees that they are having a hard time saying good-bye to her and the years of her childhood. Amid all the excitement, one often hears the parents telling someone how quickly the twenty years have passed: "Why, it seems that she just entered school a little while ago!" We also know that a father may be acutely jealous about giving up his daughter to another man, and, similarly, the mother may have pangs about her son's new life.

Another emotion I watch for is that of old friends seeing each other again.

You may think that it does not matter whether I recognize these emotions in the participants of a wedding, but I think it helps me to be human

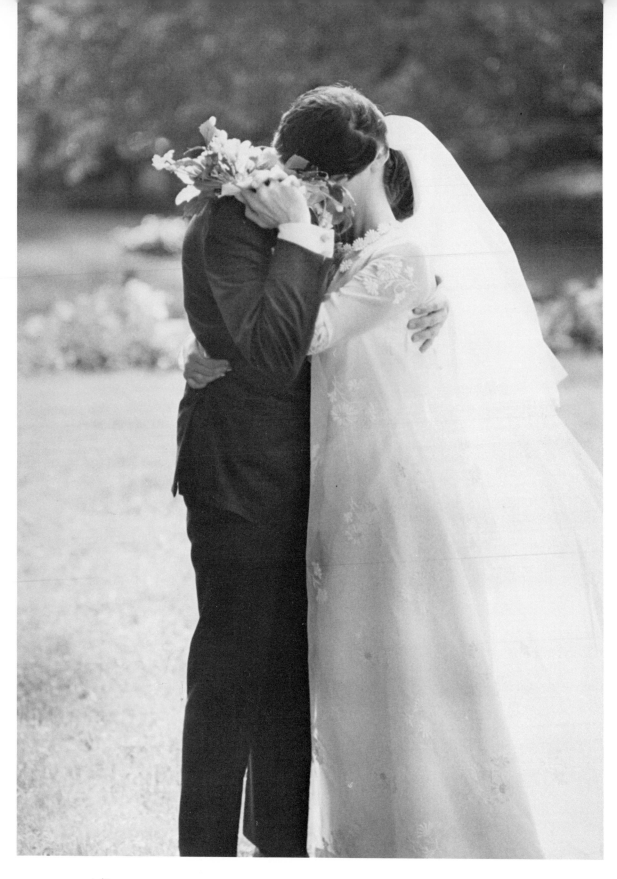

140

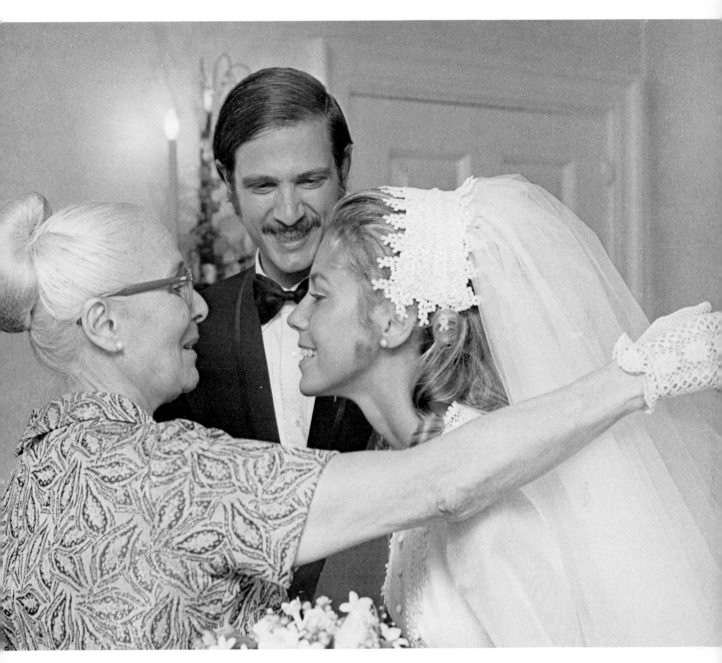

My idea of a candid wedding photograph. Grandmother, bride, and groom united in genuine love. They had forgotten that I was there taking pictures.

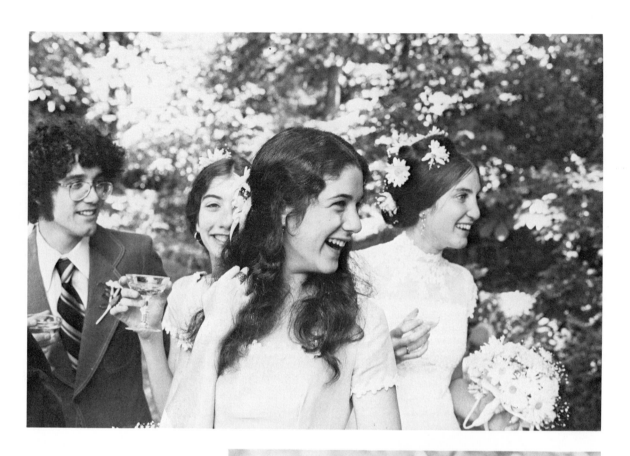

One of the most emotional
weddings I have ever
photographed: The bride was the
oldest of four daughters, and her
three sisters alternately laughed
and cried during the whole
afternoon.

142

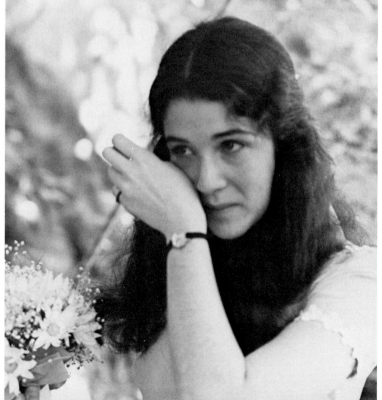

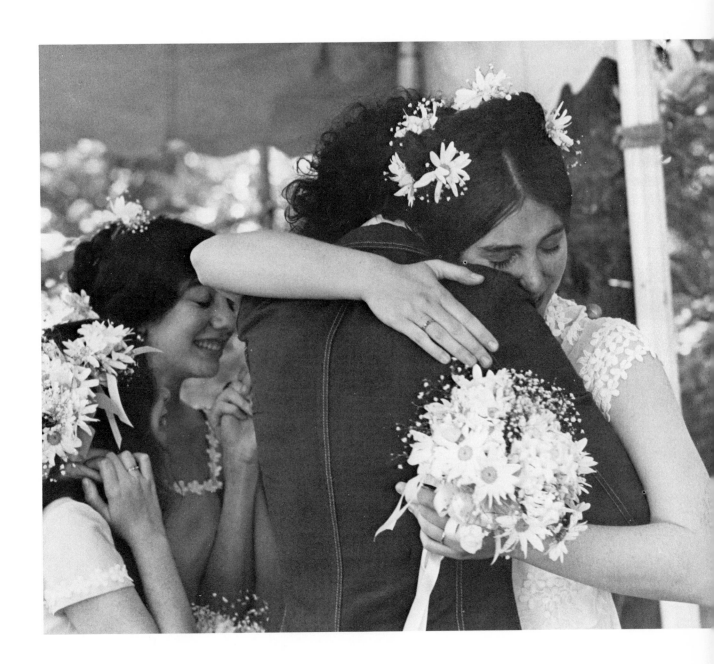

at a wedding, and also to take better pictures. True, not everybody likes to be reminded that he or she was close to tears at a certain point, but I am glad to say that many couples order photographs in which real emotions show.

Funny things often happen at weddings too. That's why I look forward to such occasions with anticipation; each one is different, unpredictable, and interesting.

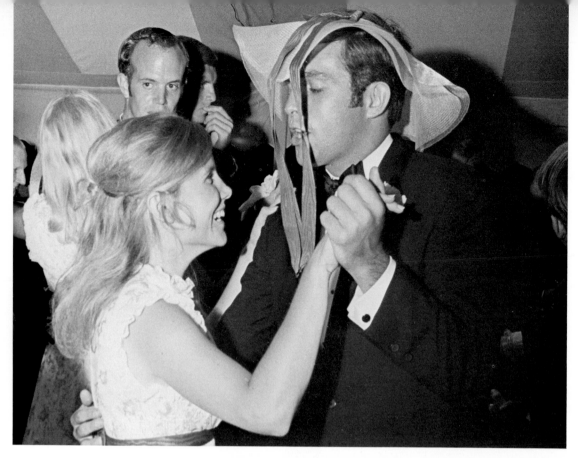

There's lots of fun at weddings. I am always on the lookout for humorous scenes, but I never pose them. Here, the best man had just appropriated the maid of honor's hat during a dance. They were having fun, and so was the bride's son, who brought his pet snake in from the garden, to the discomfiture of other guests. At right, a funny cake.

144

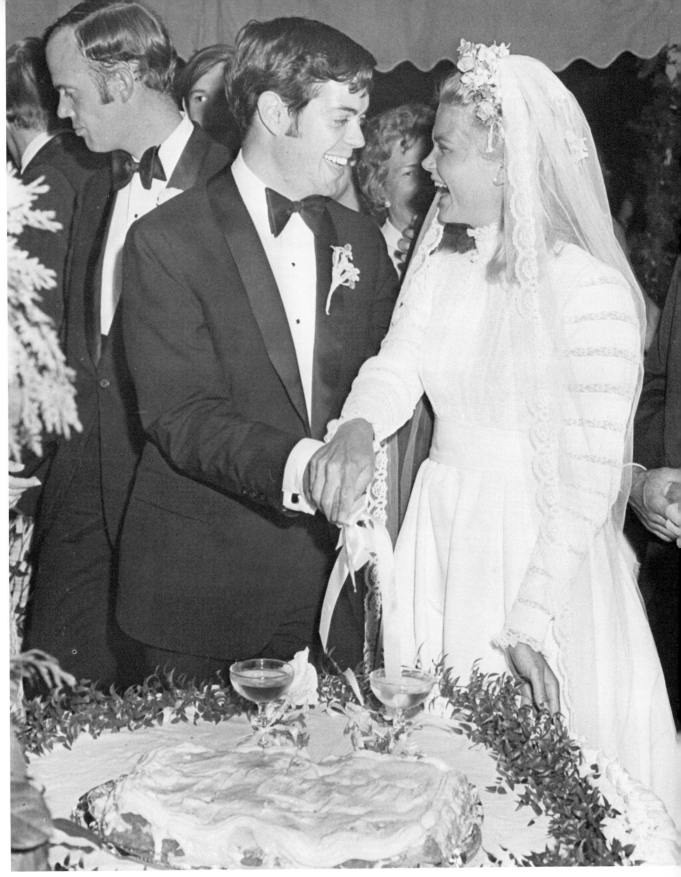

What did this man say to this woman?

And what is this usher thinking? I can't tell
you because I was using a telephoto lens, not
a microphone. I wanted to show you such
scenes, hoping to inspire you to be on the
lookout for offbeat emotions. Right: An
emotional father-daughter dance. Direct
speedlight.

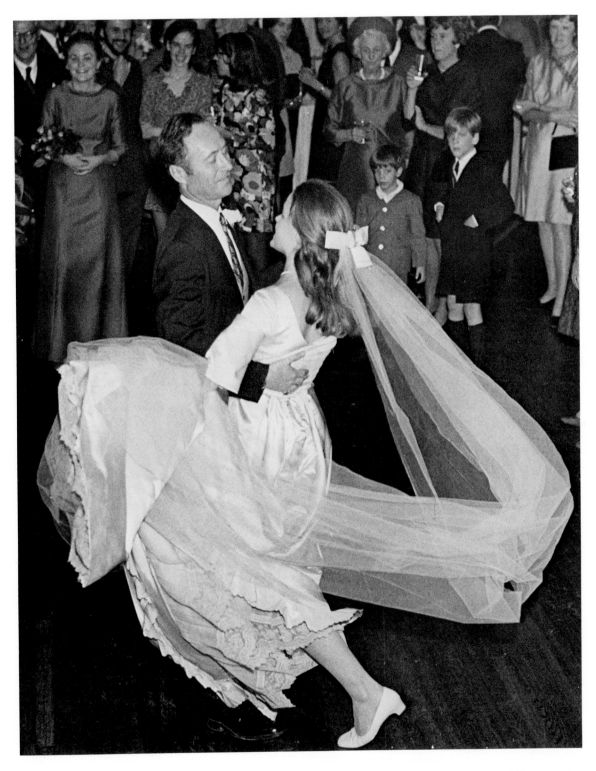

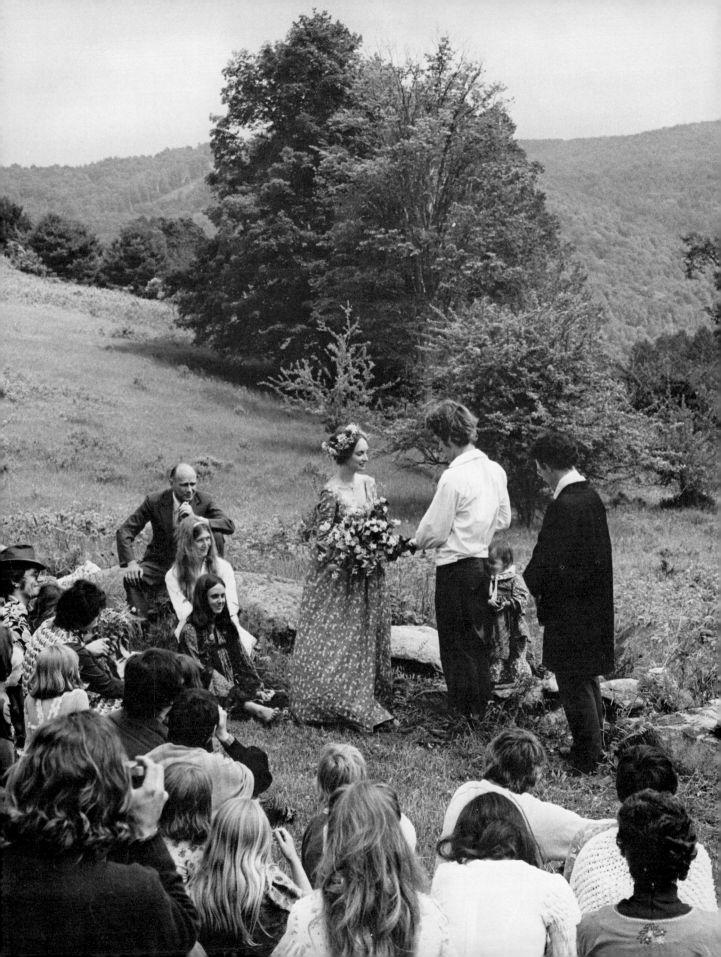

An Unusual Wedding

Nothing could have pleased me more than the news that a friend of mine was getting married in Vermont, and that she wanted me to photograph her wedding.

She seemed quite mysterious about it. "You'll see, it will be a wonderful wedding" was all she would say. I kept hearing about lots of singing and dancing, hundreds of invited guests, many arriving from all over the country to be put up on neighboring farms, and so on.

As I knew that my friend's lovely but tiny house stood alone on a large farm, I only hoped that the weather would cooperate and that we would be able to use the garden.

When the day dawned, the forecast was for heavy rain. Arriving guests spoke of rain all the way up to the small mountain where we were. But the weather held out for the wedding in the fields, the cake and champagne on top of the mountain, the outdoor supper, the lovely singing and enthusiastic dancing in the garden. Then it started to pour. But by then I had had the opportunity to take many pictures in my favorite kind of light: soft and hazy.

I shot both color and black-and-white, so I carried two heavy camera bags as gracefully as I could on the long trip through the woods, up and down hills and valleys. Fearing the rain, I also carried enough plastic sheeting to cover my camera bags if necessary. I also taped together a makeshift "raincoat" for one of my cameras so that I would be able to continue photographing if it started to pour during the ceremony.

It was interesting to photograph a wedding that observed none of the rules I knew: The couple said their own vows and then explained why they wanted to get married and what they expected from the marriage. The cake was homemade, and the guests dressed country style. The bride had made her own headdress from flowers picked earlier, and the only attendant was her beautiful little daughter from a former union.

The only posed picture of the day was of the four-generation group that I coaxed to stay together for about 90 seconds.

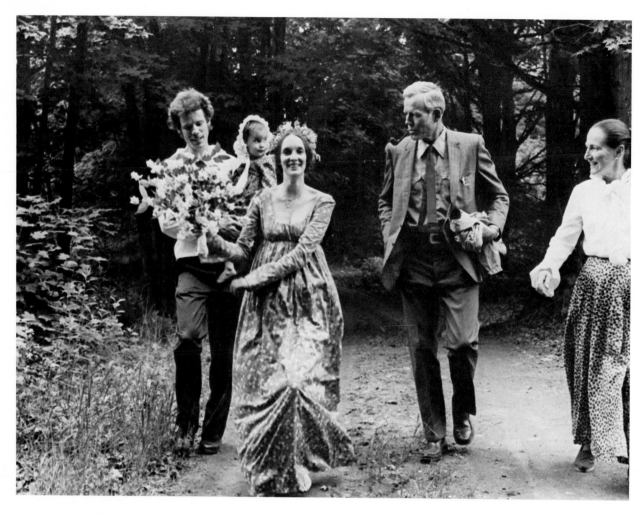

Above: Bride and groom, his parents, and the bride's little daughter on their way to the wedding. 1/250 sec. at f/5.6, Tri-X. Right: The bride's child from a former union in her wedding finery. She loved being a participant in the wedding, in the center of all the excitement. Daylight indoors, 1/60 sec. at f/4, Tri-X rated at ASA 800.

I couldn't help but smile to myself a bit when I thought of what a dyed-in-the-wool wedding photographer would have made of this day, with no possibility for taking the usual, obligatory "dream shots" each wedding is supposed to have.

I really enjoyed this wedding with its atmosphere of spontaneity and fun; the unpretentious but delicious food; lots of real flowers in simple arrangements; the lovely quality of the singing toasts and country dances. And were I ever to be married again, this is the wedding I would wish for myself.

If only all weddings were this easy to photograph! The cloudy skies produced soft light, which made it possible to shoot in any direction. It was all so informal that I didn't have to worry about disturbing anyone, and the people were genuinely gay and happy. Normal lens on my Minolta, 1/250 sec. at f/8, Plus-X.

152

The bride is a marvelous dancer who has involved her daughter in dancing since she was a baby. Many guests played recorders and guitars, others danced to this live music in traditional English country style. 1/250 sec. at f/8, Plus-X.

154

155

The Business Side
of Wedding Photography CHAPTER 15

There are several ways of getting into professional wedding photography, none of them easy.

1. Take a job with an established studio; learn the ropes, then start your own business in another location. For this, you must find a studio that will not only give you a job, but also an opportunity to learn everything about the technical, human, and business aspects. You will also need some capital: enough to live on for six months or so, plus what it costs to set up a modest business. I can only imagine doing this where I would have some friends and acquaintances on whom I could count to recommend me to their friends.

2. Work in all branches of photography—industrial, child and adult portraiture, *and* weddings—without specializing in any of them. This way of operating will cost you more in money for equipment, but it should also keep you from getting bored. One other advantage: If they have come to know and like you, the same people who hire you to photograph their new office one day may ask you to shoot the wedding of their daughter a week later. You must be really knowledgeable about all phases of photography and enjoy the challenge of being a versatile professional.

3. Do documentary photography by choice, and wedding photography to supplement your income. Your training as a photojournalist should come in handy, but you cannot count on shooting weddings without learning to use photographic lighting well. People may admire moody, half-lit, grainy photographs of others, but they will want to see their own faces shown as flatteringly as possible. If you start this way, your best chance to develop a clientele will usually lie in the recommendations that one person gives to another. For instance, bridesmaids who have seen and liked your work may choose you to photograph their own weddings later.

SALESMANSHIP AND PROMOTION

However you start, you will need two additional things in order to make a living: *salesmanship and promotion.*

I cannot teach you hard sell; I am not good at it. I like to let my pictures speak for me. When someone calls me for a job, I show a collection of my favorite wedding pictures. Since I do many kinds of photography, I don't have a fixed portfolio. Rather, my pictures are mounted on light boards, and I show them in photo paper boxes covered imaginatively in different patterns of contact-type self-adhesive covering. Depending on the job, I can put together different portfolios in minutes. I always include both color and black-and-white prints in different sizes.

I wrote the story of my first wedding coverage (shown here in Chapter 4) for *Popular Photography* magazine. The resultant printed layout became a handy promotion piece for me. Other magazines, like *Studio Photography* and *The Rangefinder,* may be interested in hearing from you if you feel you are doing something exciting and/or new in wedding photography. Your local paper may welcome a short article with pictures. But be sure you have obtained your subjects' permission to have their photographs published!

Salesmanship and promotion are often treated in the trade press, which advises the use of newspapers for advertising and for watching engagement announcements as a source to be followed up.

Money Matters

In order to decide what to charge for your work, you must first know what you spend on a wedding coverage in material and time. The prices I quote here will probably be outdated shortly. Photographic supplies have recently become so much more expensive that I have had to revise my prices several times to keep up with theirs.

Whether you give out your film to be processed or do it yourself, the cost must be pegged to prices charged by professional photofinishers. After all, they have already figured out for us all the expenses involved, so I will take their current prices to figure out what a wedding coverage costs me. Besides materials, these prices include my time or what I may have to pay an assistant.

8 rolls of 35mm 36-exposure black-and-white film, @ $1.25 a roll	$10.00
Developing, @ $1.50 a roll	$12.00
Contact prints, @ $1.50 each*	$12.00
Twenty 8'' × 10'' enlargements, @ $2.25	$45.00
Transportation (minimum)	$ 5.00
Photofloods and/or flashbulbs and/or batteries	$10.00
Total	$94.00

*Contact prints: I make my own and always make two sets: one for my files and one for the client. You'd think that their having all the shots I have taken, but in the small, 35mm size, would cut down on orders; quite the contrary. And as for me, I like to have a set of contact prints partly to facilitate telephone orders (by number) and partly because I am interested in keeping and filing all my work.

I did not add the price of an album because, usually, my customers buy it themselves. I don't do enough weddings to carry a selection of albums, but if I supply it, you will have to add that cost to the $94.00.

If the client wants the whole job shot in color, the expense sheet might look like this:

6 rolls of 35mm 36-exposure Vericolor II, Type S, @ $2.30	$ 13.80
Kodak processing, @ $2.20 a roll	$ 13.20
Jumbo printing of all shots, @ 32¢ each*	$ 68.00
Twenty 5" × 7" prints, @ $2.00	$ 40.00
Flashbulbs and/or batteries	$ 10.00
Transportation (minimum)	$ 5.00
Total	$150.00

*Jumbo printing: When presenting the color, I supply the client with Kodak's jumbo prints of every good shot rather than having contact sheets made. The larger size will produce a bigger print order, and the price difference is made up easily: Except for the first eight, which come with the package, the client pays $2.00 for each jumbo print he or she keeps.

If you use my system and shoot black-and-white *plus* some color, the expense sheet will look like this:

6 rolls black-and-white film, @ $1.25	$ 7.50
Developing, @ $1.50	$ 9.00
Contact prints	$ 9.00
15 black-and-white enlargements, @ $2.25	$ 33.75
2 rolls color, with developing and jumbo printing, @ $16.00 a roll	$ 32.00
Five 5" × 7" color enlargements, @ $2.00	$ 10.00
Total	$100.25

How much to charge for extra prints? My guideline is to double what it would cost me to have them printed. Right now, an 8" × 10" black-and-white costs $4.50, a color 5" × 7", $3.50, and so on.

You will have to decide for yourself what you want to charge for your time. I add $200.00 to whatever it costs me for a complete wedding coverage.

Now let's look at the arrangement from the client's point of view. Here is what they get:

1. About 150 to 250 shots in black-and-white and color.

2. A complete set of non-fading contact prints in black-and-white, and a set of jumbo prints in color (of which the first eight are free).

3. Twenty enlargements up to 8" × 10" in black-and-white, 5" × 7" in color. The enlargements are fully finished when I first present them, but they can be exchanged for others of the client's choice. This procedure sounds chancy, but I never get back more than three or four of my carefully chosen

enlargements. And after they see what the pictures look like enlarged, they are more willing to study the small 35mm contact sheets with a magnifier for additional choices.

Unless I know the family personally, I ask for half my fee in advance. It is probably advisable to deliver the order personally and get paid fully at that point, but I often mail orders and trust that a check will follow; my trust has never been misplaced.

Conclusion

I have never been happier in my work as a photographer than during periods when I was discovering something new with my camera. When I started, I explored the world of children, which resulted in many picture stories and illustrations about them (for example, *Child Photography Simplified,* recently published by Amphoto).

When a little kitten adopted me, I immediately began to document her life and how she brought up her own babies. The book about her was called *The Silent Miaow,* and as it is the only book I know of that treats an animal like a person and shows everything about her life; it is a real success, selling briskly even after 15 years.

As I mentioned earlier, I got into wedding photography when a friend of mine asked me to photograph her daughter's wedding. (I had first met the bride-to-be when she was six years old, and had photographed her many times since.) I dove right in, very excited. I felt that missing an important shot would be much more than a photographic goof—it would also be a real loss in the lives of this couple. As a result of photographing this one wedding, I received more and more requests for wedding coverage, until I felt that I had enough photographs and experiences and ideas to do this book.

In it, I used two kinds of photographs: my favorites, on the one hand, and those which illustrate technical points, on the other.

I hope you were able to learn something from this book; but even more, I hope that you have caught some of my enthusiasm for documenting such an important event in the lives of the people who are our subjects.